LEICA

THE LEICA LENS BOOK

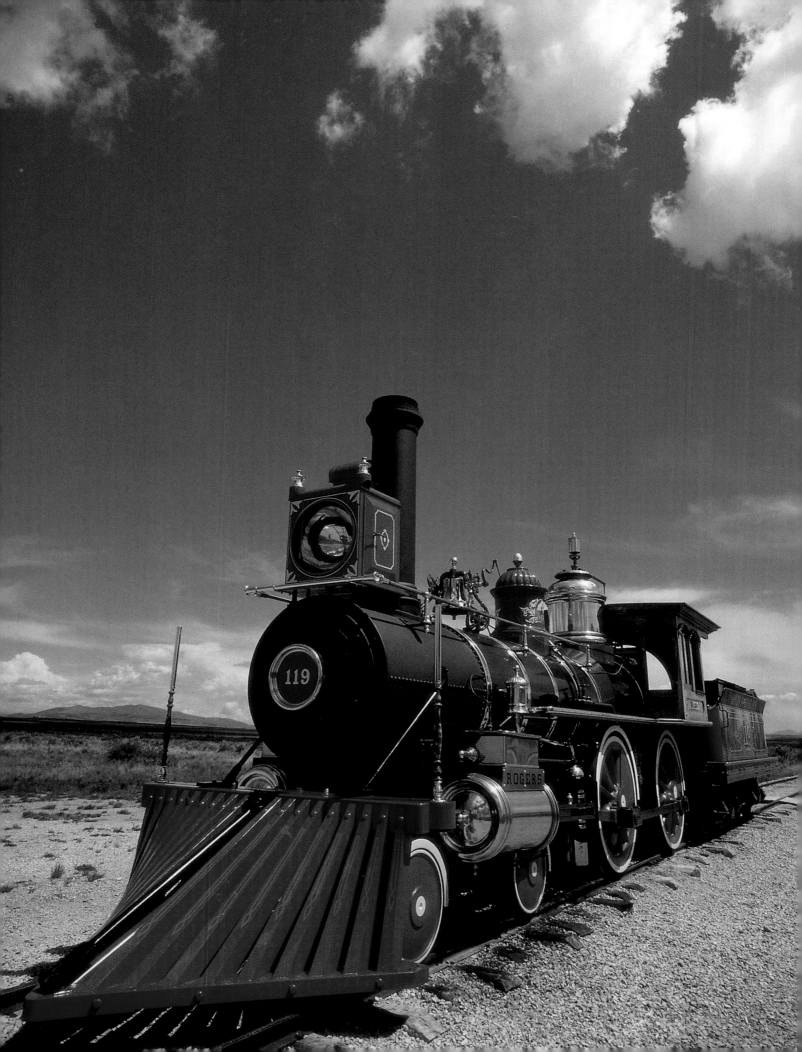

THE LEICA LENS BOOK

BRIAN BOWER

David & Charles

A DAVID & CHARLES BOOK

First published in the UK in 1998

Copyright © Brian Bower

A catalogue record for this book is available from the British Library.

ISBN 0 7153 0817 3

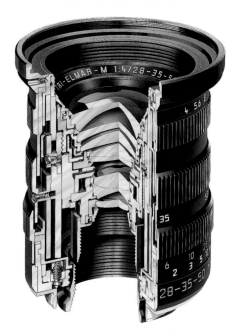

Designed by Paul Cooper

Printed in Singapore by C.S. Graphics Pte Ltd.
for David & Charles
Brunel House
Newton Abbot
Devon

All photography by Brian Bower FRPS unless otherwise stated.

page 2
LOCOMOTIVE, GOLDEN SPIKE, UTAH, USA
A great subject, dynamic perspective from top quality ultra wide angle lens, wonderful light
and the sharpest, finest grained film all add up to a picture that oozes quality. **Leica R5,
21/4 Super Angulon, 1/125 sec at f5.6/8, Kodachrome 25 Professional**

CONTENTS

FOREWORD

The most important link in the chain from the photographer's mind and eye to the final image is undoubtedly the lens. Any serious photographer knows that there are lenses and there are **the** lenses. Without doubt Leica lenses are special – they have an almost indefinable quality that is acknowledged even by photographers who work with other camera systems. It has to do with something more than sharpness: it is a 'correctness' of the image, an ability to differentiate subtle nuances of tone and colour, a lack of harshness in out-of-focus areas that enhances the sharply focused subject, and a luminosity that was once best described by a dealer friend of mine as 'built-in sunshine'.

That was many years ago when I bought my first Leica, an M2, and lenses. The lens quality was a revelation that only added to the pleasure of working with a wonderful precision instrument – a real encouragement to improving my photography. Since then I have been fortunate to have had opportunities to use or try successive developments of Leica lenses, and I have never ever been disappointed with the results. With both rangefinder and reflex camera systems they have given me remarkable images of people, places, interests and events of all kinds.

I hope that this book will stimulate and help photographers to choose well, and then go out and use those wonderful Leica lenses, new or old, as they were intended – for making pictures.

BRIAN BOWER

FALL COLOURS, MAINE, USA
Fall is a wonderful time for colour photography in New England. Here, in order to exclude other distracting elements, I moved in close with a 21mm lens on my M6. **Leica M6, 21/2.8 Elmarit 1/125 sec at f5.6, Kodachrome 25 Professional**

LEICA – THE BACKGROUND

The Leica was not the first still camera to use the 35mm cine film that became available in the early part of this century, but when it came on the market in 1925 it was the first to achieve success both technically and commercially. There were three main reasons for this.

First was Oskar Barnack's camera design – compact and easy to use, yet built with the precision required to follow through his concept of 'small negative, big print'.

MAX BEREK

While it was the original genius of Oskar Barnack that created the Leica camera and established the concept of 35mm photography, an absolutely key element in its success was the remarkable quality of the 50mm Elmar and other early lenses. Berek was the man responsible for the Elmar, Hektor, Thambar, Summar, Summitar and Summarex that secured the outstanding reputation of Leica camera lenses.

Photo Leica Arkiv

THE THIRTIES

A crucial element in the success of the Leica system was the introduction of a comprehensive range of lenses with informative literature to promote and aid their use.

Leica R8, 100/2.8 Apo-Macro, Ektachrome 100SW, 1 sec f22

THE 50MM F3.5 ELMAR

Max Berek's classic Elmar was the lens that established the lens quality standards that made the Leica famous and ensured the viability of the 35mm format.

Leica R, 100/2.8 Apo-Macro, Kodak T-Max 400CN, 1/4 sec f22

Second was the quality of the lens that was fitted to the camera. Barnack's colleague Max Berek had specially designed the 50mm Elmax and Elmar, which achieved the remarkable optical quality that provided incredible detail in the tiny 24x36mm negatives.

Third was Barnack's continued development of the Leica into a 'system' with accessories, a coupled rangefinder and a range of first-class interchangeable lenses that fitted the Leica for a huge range of photographic applications.

Following the pioneering Leica, 35mm cameras have become the norm, other formats the exception. At the same time, the basic range of lens focal lengths established in the early days of the Leica is still the cornerstone of many manufacturers' 35mm systems.

The original Leica rangefinder line lives on in the highly developed 'M' system, while the 35mm single-lens reflex

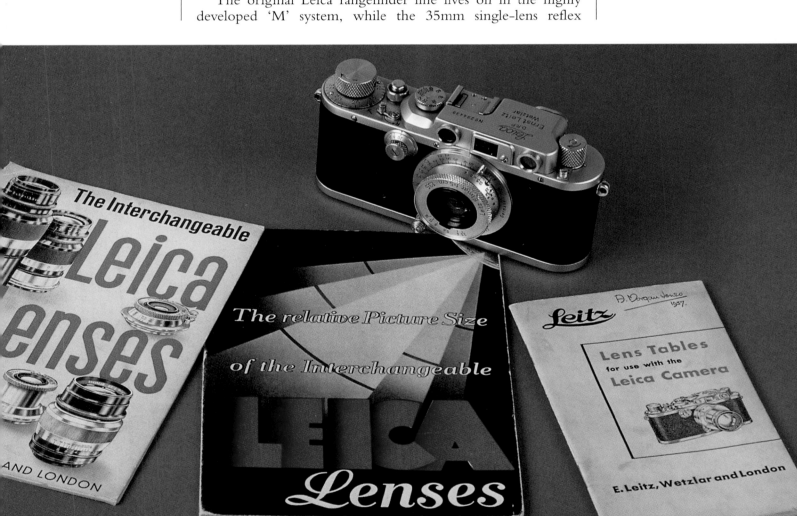

LEICA RANGEFINDER DEVELOPMENT

The Leica II of 1932, the first Leica with a built-in coupled rangefinder, stands alongside the 1998 M6.
Leica R8, 100/2.8 Apo Macro Elmarit, 1/4 sec at f16, Kodak T 400 CN

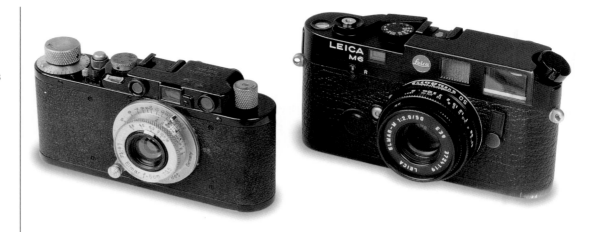

LEICA REFLEX DEVELOPMENT

The Leicaflex II of 1966 compared with the sophisticated 1996 R8.
Leica R8, 100/2.8 Apo Macro Elmarit, 1/4 sec at f16, Kodak T 400 CN

camera which eventually came to dominate the 35mm scene is now represented by the highly sophisticated Leica R8.

The development of the various rangefinder and R camera models is summarized in the tables on pages 11–13. These tables also show the lens cam compatibility for the various R models and the viewfinder arrangements for the rangefinder models. Note that the screw-mount rangefinder cameras will only accept screw-mount lenses, but the M cameras will accept screw-mount lenses fitted with the appropriate screw to an M bayonet adapter.

LEICA M RANGEFINDER CAMERAS								
Model	Available from–to	Lens Fittings	Rangefinder/viewfinder	Built-in metering system	Motor winder	Shutter speed	Comment	
LEICA M3	1954–1967	Leica M	yes 50/90/135mm	none	no	Mechanical manual 1–1/1000 sec	higher magnification rangefinder/viewfinder	
LEICA MP	1956–1967	Leica M bayonet standard	yes 50/90/135mm	none	no	Mechanical manual 1–1/1000 sec		
LEICA M2	1958–1967	Leica M bayonet standard	yes 35/50/90mm	none	no	Mechanical manual 1–1/1000 sec		
LEICA M1	1959–1964	Leica M bayonet standard	none 35/50mm	none	no	Mechanical manual 1–1/1000 sec		
LEICA MD	1963–1966	Leica M bayonet standard	none	none	no	Mechanical manual 1–1/1000 sec		
LEICA M2 Mot	1966	Leica M bayonet standard	yes 35/50/90mm	none	Special	Mechanical manual 1–1/1000 sec		
LEICA M4	1967–1975	Leica M bayonet standard	yes 35/50/90/135mm	none	no	Mechanical manual 1–1/1000 sec		
LEICA MDa	1966–1976	Leica M bayonet standard	none	none	no	Mechanical manual 1–1/1000 sec		
LEICA M4 Mot	1968–1971	Leica M bayonet standard	yes 35/50/90/135mm	none	Special	Mechanical manual 1–1/1000 sec		
LEICA M5	1971–1975	Leica M bayonet standard	yes 35/50/90/135mm	yes	No	Mechanical manual 1–1/1000 sec		
LEICA CL	1973–1976	Leica M bayonet standard	yes* 40/50/90mm	yes	No	Mechanical manual 1–1/1000 sec	* short base length unsuitable for lenses faster than f2 (50mm) or f4 (90mm)	
LEICA M4-2	1978–1980	Leica M bayonet standard	yes 35/50/90/135mm	none	Winder M4-2	Mechanical manual 1–1/1000 sec		
LEICA MD-2	1977–1987	Leica M bayonet standard	none	none	Winder M4-2	Mechanical manual 1–1/1000 sec		
LEICA M4-P	1981–1987	Leica M bayonet standard	yes 28/35/50 75/90/135mm	none	Winder M4-P	Mechanical manual 1–1/1000 sec		
LEICA M6	1984–	Leica M bayonet standard	yes 28/35/50 75/90/135mm	yes	Winder M	Mechanical manual 1–1/1000 sec		
LEICA M6J	1994	Leica M bayonet standard	yes 35/50/90/135mm	yes	Winder M	Mechanical manual 1–1/1000 sec	limited edition M3 anniversary model with higher magnification finder	
LEICA M6/0.85	1998–	Leica M bayonet standard	yes 35/50/75 90/135mm	yes	Winder M	Mechanical manual 1–1/1000 sec	new design higher–magnification finder	

LEICA REFLEX CAMERAS 1965-1998								
Model	Available from–to	Lens fitting/cam	Operating modes	Metering systems	Maximum meter sensitivity	Shutter speeds (sec)	Weight (g)	Comment
LEICAFLEX I/II	1965–1968	S, T, TR	M	non–TTL	+4 EV	mechanical manual 1–1/2000	850	non-interchangeable screen, focus only on central microprism
LEICAFLEX SL	1968–1974	T, TR	M	S	+3 EV	mechanical manual 1–1/2000	850	non-interchangeable fine microprism screen with coarse central spot
LEICAFLEX SL Mot	1972–1974	T, TR	M	S	+3 EV	mechanical manual 1–1/2000	1550	non-interchangeable fine microprism screen with coarse central spot
LEICAFLEX SL2	1974–1976	T, TR	M	S	0 EV	mechanical manual 1–1/2000	770	non-interchangeable microprism screen with central rangefinder spot
LEICAFLEX SL2 Mot	1975–1976	T, TR	M	S	0 EV	mechanical manual 1–1/2000	1470	non-interchangeable microprism screen with central rangefinder spot
LEICA R3	1976–1980	R, TR, R8	M, AA	S, A	S, +1 EV A, +1 EV	electronic manual 4–1/1000 auto 4–1/1000	780	non-interchangeable microprism screen with central rangefinder spot
LEICA R3 Mot	1978–1980	R, TR, R8	M, AA	S, A	S, +1 EV A, +1 EV	electronic manual 4–1/1000 auto 4–1/1000	780	non-interchangeable microprism screen with central rangefinder spot
LEICA R4	1980–1987	R, TR, R8	M, AA, AS, P	S, A	S, +3 EV A, +1 EV	electronic manual 1–1/1000 auto 8–1/1000	630	5 interchangeable focusing screens
LEICA R4S	1983–1986	R, TR, R8	M, AA	S, A	S, +3 EV A, +1 EV	electronic manual 1–1/1000 auto 8–1/1000	630	5 interchangeable focusing screens
LEICA R4 Mod2 (P)	1986–1988	R, TR, R8	M, AA	S, A	S, +3 EV A, +1 EV	electronic manual 1–1/1000 auto 8–1/1000	630	5 interchangeable focusing screens
LEICA R5	1987–1992	R, TR, R8	M, AA, AS, VP	S, A, DF	S, +3EV A, +1 EV	electronic manual 1/2–1/2000 auto 15–1/2000	625	5 interchangeable focusing screens
LEICA R6	1988–1992	R, TR, R8	M	S, A, DF	S, +3 EV A, +1 EV	mechanical manual 1–1/1000	625	5 interchangeable focusing screens
LEICA RE	1990–1993	R, TR, R8	M, AA	S, A, DF	S, +3 EV A, +1 EV	electronic manual 1/2–1/2000 auto 15–1/2000	625	5 interchangeable focusing screens
LEICA R6.2	1992–1997	R, TR, R8	M	S, A, DF	S, +2 EV A, 0 EV	mechanical manual 1–1/2000	625	5 interchangeable focusing screens
LEICA R7	1992–1997	R, TR, R8	M, AA, AS, VP	S, A, DF	S, +2 EV A, 0 EV	electronic manual 4–1/2000 auto 16–1/2000	670	5 interchangeable focusing screens
LEICA R8	1996–	R, TR, R8	M, AA, AS, VP, F	S, A, MF, DF	S, -4 EV A, -2 EV MF, -2 EV	electronic manual 16–1/8000 auto 32–1/8000	890	5 interchangeable focusing screens 1/250 sec flash synch

LENS CAMS: S = single cam, T = twin cam, R = R cam, TR = triple cam (twin cam plus R cam), R8 = R cam plus electrical contacts

MODES: M = manual, AA = aperture priority automatic, AS = shutter speed priority automatic, P = programme automatic, VP = variable programme automatic, F = flash measurement

METERING SYSTEMS: S = spot/selective, A = averaging, MF = multiple field, DF = dedicated flash (TTL).

	LEICA SCREW-MOUNT RANGEFINDER CAMERAS					
Model	Available from–to	Lens fitting	Rangefinder/viewfinder	Motor Winder	Shutter speeds (sec)	Comment
LEICA I USA model A	1925–1932	fixed	none/50mm	no	Mechanical manual 1/20–1/500	
LEICA I Compur USA model B	1926–1931	fixed	none/50mm	no	Mechanical manual 1–1/300	
LEICA I interchangeable USA model C	1931–1932	Leica screw non-standard	none/50mm	no	Mechanical manual 1/20–1/500	
LEICA II USA model D	1932–1947	Leica screw standard	none/50mm	Mooly ★	Mechanical manual 1/20–1/500	★ fits cameras above s/n 159000
LEICA standard USA model E	1932–1947	Leica screw standard	none/50mm	Mooly ★	Mechanical manual 1/20–1/500	★ fits cameras above s/n 159000
LEICA III USA model F	1933–1942	Leica screw standard	yes/50mm	Mooly ★	Mechanical manual 1–1/500	★ fits cameras above s/n 159000
LEICA IIIA USA model G	1935–1938	Leica screw standard	yes/50mm	Mooly ★	Mechanical manual 1–1/1000	★ fits cameras above s/n 159000
LEICA IIIB	1938–1945	Leica screw standard	yes/50mm	Mooly	Mechanical manual 1–1/1000	
LEICA IIIC	1940–1951	Leica screw standard	yes/50mm	Mooly-C	Mechanical manual 1–1/1000	
LEICA IIID	1940–1945	Leica screw standard	yes/50mm	Mooly-C	Mechanical manual 1–1/1000	
LEICA IIC	1948–1951	Leica screw standard	yes/50mm	Mooly-C	Mechanical manual 1/30–1/500	
LEICA IC	1949–1952	Leica screw standard	none	Mooly-C	Mechanical manual 1/30–1/500	
LEICA IIIF black synchro dial	1950–1952	Leica screw standard	yes/50mm	Mooly-C	Mechanical manual 1/20–1/500	
LEICA IIF black synchro dial	1950–1952	Leica screw standard	yes/50mm	Mooly-C	Mechanical manual 1/30–1/500	
LEICA IF black synchro dial	1950–1952	Leica screw standard	none	Mooly-C	Mechanical manual 1/30–1/500	
LEICA IIIF red synchro dial	1952–1954	Leica screw standard	yes/50mm	Mooly-C	Mechanical manual 1–1/1000	
LEICA IIF red synchro dial	1952–1957	Leica screw standard	yes/50mm	Mooly-C	Mechanical manual 1/25–1/1000	
LEICA IF red synchro dial	1952–1957	Leica screw standard	none	Mooly-C	Mechanical manual 1/25–1/1000	
LEICA IIIF red synchro dial, delayed action	1954–1957	Leica screw standard	yes/50mm	Mooly-C	Mechanical manual 1–1/1000	
LEICA IIIG	1957–1960	Leica screw standard	yes/50mm 90mm	no	Mechanical manual 1–1/1000	
LEICA IG	1957–1960	Leica screw standard	none	no	Mechanical manual 1–1/1000	

BUILT–IN METERING SYSTEMS: None for all

Chapter 2

TECHNICAL MATTERS

Over the years, Leica have maintained an enviable reputation for producing superior photographic lenses, many of which have been optical landmarks. The original 50mm Elmar is an acknowledged classic; the first Summicron of 1953 established remarkable new levels of performance for standard lenses. In 1968, the 50mm f1.2 Noctilux became the first production lens to use aspheric elements, and the successor 50mm f1 of 1976 the fastest-ever lens in regular production. Within the reflex system, the 180mm f3.4 Apo Telyt set astonishing new standards for lenses of its class, as did the 280mm f2.8 Apo Telyt of 1983 and the 100mm f2.8 Apo Macro Elmarit of 1987. More recently, the ASPH lenses for the Leica M have successfully exploited new design and production technology. Many of these achievements resulted from Leica having the foresight to establish their own research laboratory to investigate and develop new qualities of optical glass. For the more sophisticated lens designs, glasses of anomalous partial dispersion and high refractive index are essential and Leica led the way in developing these.

AL HAJJARAH, YEMEN
The image quality obtainable from Leica lenses is legendary, as is their robust mechanical construction. From the very beginning they have been favourites of travel photographers.
Leica M6, 35/2 Summicron, 1/125 sec at f5.6, Kodachrome 25 Professional

SUMMICRON AND SUMMITAR
When the first Summicron lens replaced the Summitar in 1953 it set astonishing new standards for 50mm lenses.
Leica R8, 100/2.8 Apo Macro Elmarit, 1/4 sec at f16, Kodak T 400 CN

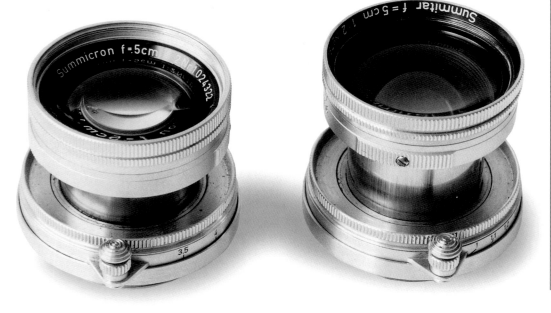

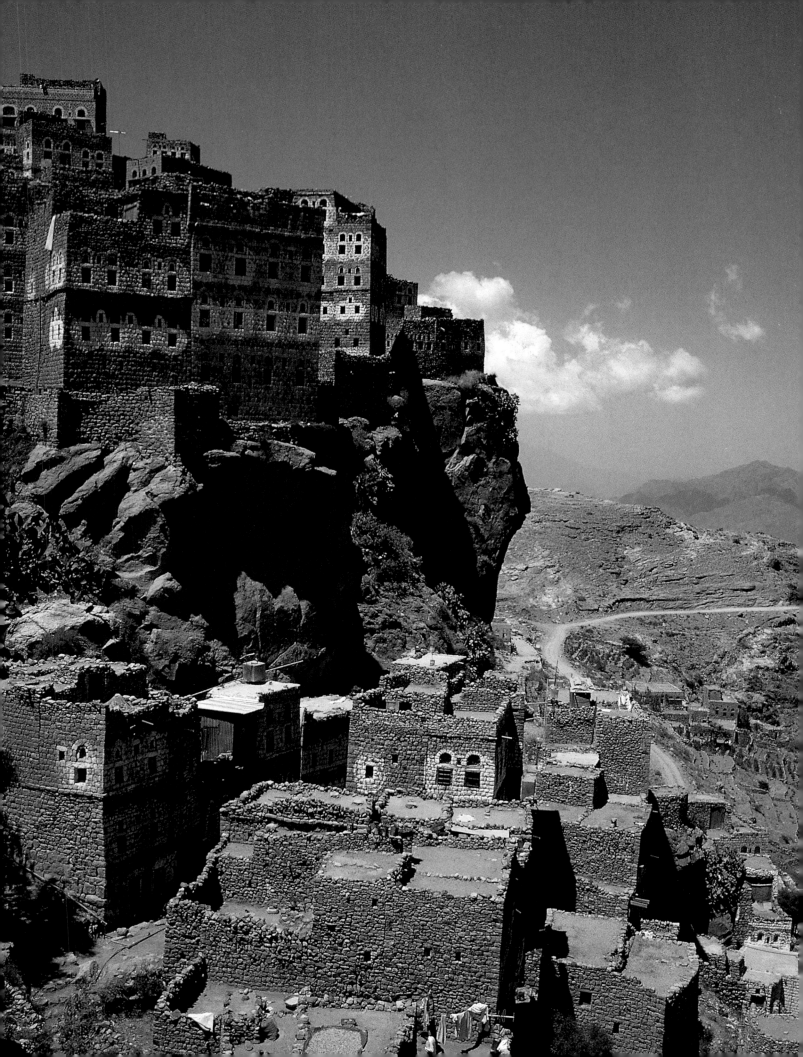

FLOWER CLOSE-UP
This flower was photographed at about half life size using the Bellows R unit. Even though the lens was stopped down to f16, the depth of field at such close range is minimal. The harmonious rendition of the out-of-focus background has what the Japanese call *Bo-ke*. **Leica R4, 65/3.5 Elmar, 1/8 sec at f16, Kodachrome 25 Professional**

IMAGE QUALITY

Leica lenses have always retained a special quality, characterized not just by sharpness and correctness of the image but also an ability to differentiate subtle hues and tonal values, combined with a remarkable luminosity. The lenses also have what the Japanese call *Bo-ke*. This describes an harmonious relationship between the sharply focused subject and the out-of-focus areas of the image, in particular the way in which out-of-focus backgrounds and foregrounds are rendered. The optical configuration of the lens, the position and shape of the diaphragm, and the way the designer has chosen to correct particular aberrations all contribute to the shape, and the

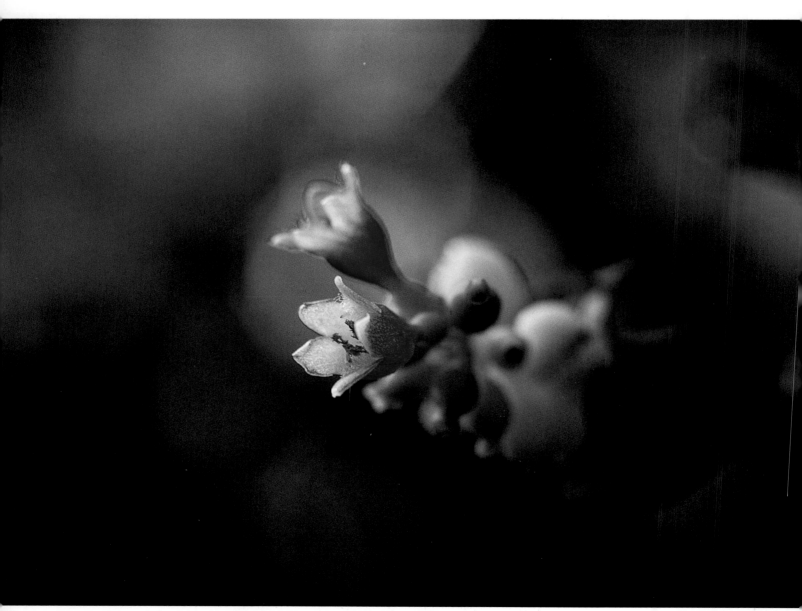

softness or harshness of these out-of-focus areas. An extreme case is the characteristic way in which mirror lenses render out-of-focus highlights as 'doughnuts'.

Bo-ke is certainly one of those qualities that together add up to that difficult-to-define 'Leica quality'. As with other subtle factors, it is not something revealed by lens test charts or MTF curves, but is obvious to experienced photographers conscious of overall image quality. This is not especially new: years ago, photographers would discuss the 'drawing' of particular lenses. Even lenses of similar construction, such as the Zeiss Tessar and the Ross Xpres, each rendered a subject subtly different from the other.

The fact is that while computer evaluation and scientific testing of many aspects of performance are essential when developing a lens design, they cannot analyse all the subtleties and complex aspects involved in reducing a three-dimensional subject to a two-dimensional image. This is true of even the most sophisticated design and test facilities, with the most highly qualified optical experts available to interpret and analyse results. Only years of experience and know-how, not to mention some human flair, will ensure that the various optical compromises involved will produce a lens that will delight photographers perhaps even more than lens testers.

In the final analysis, the best way to test a lens for photographic image quality is to go out and take pictures with it, and then compare these with those taken using an equivalent lens of known high quality. It is also important to use the lens for the purpose for which it has been designed, and for the comparisons to be valid they must be of the same subject, at the same time, with the same lighting and on the same film.

DESIGN CONSIDERATIONS

Lenses are optimized for different requirements. A wide aperture f2 or f1.4 lens, for example, will have quite different design aims from a macro lens of equivalent focal length. The prime requirements of the macro lens will be to ensure that good corrections are maintained within the extreme close-focusing range as well as for more distant subjects. It will also need to have a flat field of sharp focus with absolutely minimal distortion, as it is highly likely to be used for copying work or photographing other close-up detail on a flat plane. In order to achieve all this, it is unlikely that the maximum aperture will exceed f2.8. It is worth noting that for the more extreme close-ups – larger than life size – the special Leica Photar lenses are computed and designated for specific ranges of magnification (see Chapter 8).

Conversely, a high-speed lens such as a Summilux will not be able to perform at its best in the near range – say, below about 2m (6ft) – especially at its wider apertures. Flatness of field is not quite so critical, and some minimal distortion will be of no consequence for the kind of available-light subjects where such lenses are most likely to be used. Good contrast and

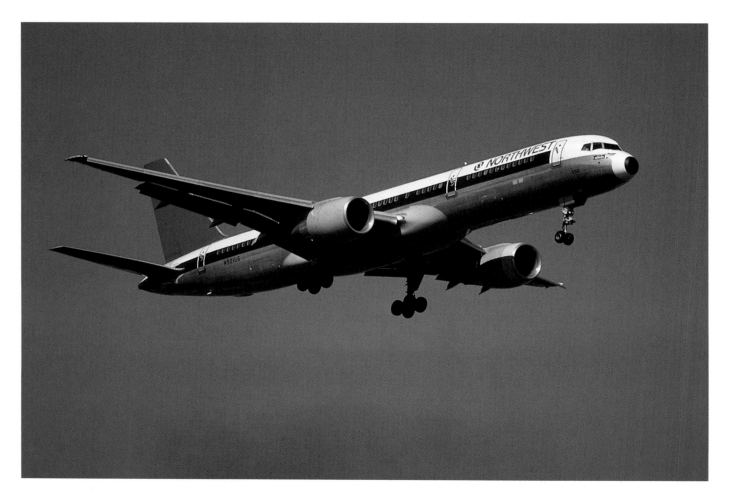

NORTH WEST AIRLINES BOEING 757

This shot was taken as the aircraft was approaching to land at Newark Airport. The '180' was the first of Leica's Apo lenses. The superb correction is clearly apparent in this picture taken at full aperture.

Leica RE, 180/3.4 Apo Telyt, 1/500 sec at f3.4, Kodachrome 25 Professional

definition, especially in the centre of the image at full aperture, and freedom from flare and reflections as well as optical aberrations such as coma will have the higher priority.

With very long and heavy lenses, other factors enter into the equation. Handling is very important, and a feature that has helped considerably in this respect is the introduction by Leica of internal focusing. Here, instead of the whole optical assembly having to move to focus, just one small group of lenses within the assembly is moved when the focusing ring is rotated. This has several advantages. First, mechanically, it is possible to make the focusing action lighter, easier and with a better close-focusing range. Second, the overall length of the lens remains unchanged so that the balance point is always the same; this is important with a heavy lens, whether hand held or on a tripod. Thirdly, the focusing group can be used as a 'floating element' to help maintain good correction throughout the focusing range.

Wide angle lenses present a different problem. With the greater angle of view, the problems of controlling distortion and minimizing vignetting increase significantly, and with wider apertures so does the correction of other optical aberrations. Just to add to the complications facing the designer, in the case of

the reflex cameras there is a further need to provide adequate 'back focus' between the rear element of the lens and the shutter, in order to provide space for the instant return mirror. This has to be achieved by a reversed telephoto (retrofocus) configuration, resulting in a much more complex design compared with the rangefinder cameras. Even with these, however, there is now a requirement to provide a clear view of the white spot on the shutter curtain for the M6 metering cell, so that in the widest (21mm, 24mm and 28mm) M lenses some degree of retrofocus design has been involved.

ASPHERIC ELEMENTS

With both very wide aperture and wide angle lenses, it has been known for some time that incorporating aspheric lens elements would enable better corrections to be achieved, with valuable improvements in performance – especially at wide apertures – with respect to image quality at the edges of the format and the reduction of artificial ('system') vignetting. The problem with aspheric elements has always been the very high cost of production. With the development and perfection of new manufacturing technologies, Leica have been able to reduce costs and incorporate aspheric elements at much more reasonable price levels.

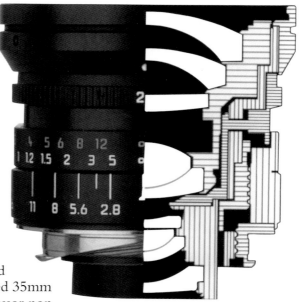

21mm f2.8 ELMARIT-M-ASPH CROSS SECTION
Photo Leica Archiv

The advantages are exemplified particularly in the recently introduced 35mm f2 Summicron M ASPH. Its predecessor non-aspheric lens is very highly regarded indeed, but the new lens demonstrates clearly superior edge quality at f2 and f2.8, and to a lesser extent at f4. The ASPH lens also achieves much-reduced 'system' vignetting at the wider apertures.

All lenses 'naturally' vignette – it is an inescapable optical law that the illumination at the edges of the image is less than at the centre. Put simply, this is because the light rays have further to travel. The wider angle the lens, the greater proportionately is this light loss. The table below shows how critical this light fall-off becomes as the angular field is increased.

Lens focal length (mm)								
21	28	35	50	90	135	180	280	400
Corner illumination as % of central illumination								
23	38	52	72	89	95	97	99	99

The lens designer can do very little to improve on these figures, but lenses also suffer from 'system' vignetting, which compounds the problem. This is the result of both the optical and mechanical construction of the lens and becomes more pronounced as the maximum aperture is increased. Leica go to great lengths to minimize 'system' vignetting, and it is generally eliminated by f4 or f5.6. With the help of ASPH elements, the designers have also reduced it greatly at f1.4, f2 and f2.8 with the latest wide angle M lenses.

APOCHROMATIC LENSES

We are all familiar with the way in which a prism splits white light into the component colours of the spectrum, from red at one end to violet at the other. The trick for the optical designer is to ensure that when a lens 'bends' the light to form an image, the different colours are still brought back to the same point of focus, otherwise the image will not be sharp. Correcting the various 'chromatic' aberrations is extremely difficult and particularly so with longer focal lengths, especially as the maximum aperture is increased. Convention has been that if a lens is corrected for two wavelengths – eg for each end of the visible spectrum, red and violet – the remaining ones will also be adequately corrected. With short to medium focal lengths there is more than sufficient depth of focus at the image plane for this to be true; this is the traditional achromatic correction. With longer focal lengths of wider aperture even a very low degree of deviation is unacceptable, and to achieve the highest image quality with all colours and maximum sharpness a further correction of the secondary red spectrum is necessary. The lens is then said to be 'apochromatic' (Apo).

LANDMARK LENSES
The 180mm f3.4 Apo Telyt of 1966 was Leica's first Apo lens and is still a stunning performer. The limited production 35mm f1.4 Summilux-M Aspherical had two aspheric surfaces manufactured using very costly conventional processes. It produced images of outstanding quality and paved the way for the ASPH lenses made possible by new and more economical production processes.
Leica R8, 100/2.8 Apo Macro Elmarit, 1/4 sec at f16, Kodak T 400 CN

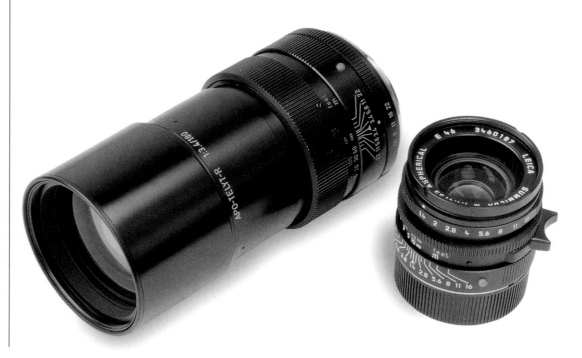

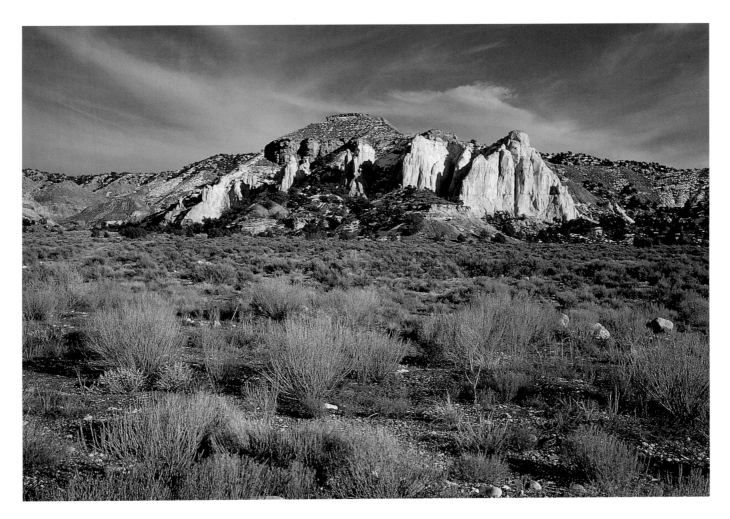

NEAR ESCALANTE, UTAH, USA

Leica's first lens to use aspheric elements was the 1966 50mm f1.2 Noctilux. The next was the 35mm f1.4 Summilux Aspherical of 1992. Both were produced in very small numbers because of the complexities of manufacture. New production techniques have now allowed Leica to bring the advantages of aspheric technology to a much wider range of lenses at an acceptable price.

Leica M6, 35/1.4 Aspherical, 1/60 sec at f8, Kodachrome 25 Professional

The improvement in quality with long, fast lenses is remarkable. However, the development and production costs of such lenses, and especially of the sophisticated glass types needed, is very high indeed. Nevertheless, Leica policy now is that the superior apochromatic correction should be applied to all longer focal length designs. The benefits can be seen clearly in the image quality, especially at wider apertures.

Leica has a very strict interpretation of what apochromatic correction is. As far as their lenses are concerned, the correction must already be effective at full aperture and right across the whole image field. Some other lens makers have rather less strict criteria: one magazine report commented that Leica's 25-year-old 560mm f6.8 Telyt, a now discontinued lens consisting of only one two-element component, met the Apo standards applied by one manufacturer!

ZOOM LENSES

Apart from the Apo lenses, much of the recent work for the R system has been concentrated on developing 'in-house' zoom lenses. The benefits are being seen clearly in the new 35–70mm f4 Vario Elmar, which also uses an aspheric element; the

FOLLOWING PAGES
LONDON FROM WATERLOO BRIDGE

It was a blustery day with fleeting splashes of sun. I had to use a faster than usual shutter speed to prevent camera shake: this meant an aperture of f4 but the aspheric design maintains quality right to the edges of the frame.

Leica M6, 35/2 Summicron ASPH, 1/250 sec f4, Kodachrome 25 Professional

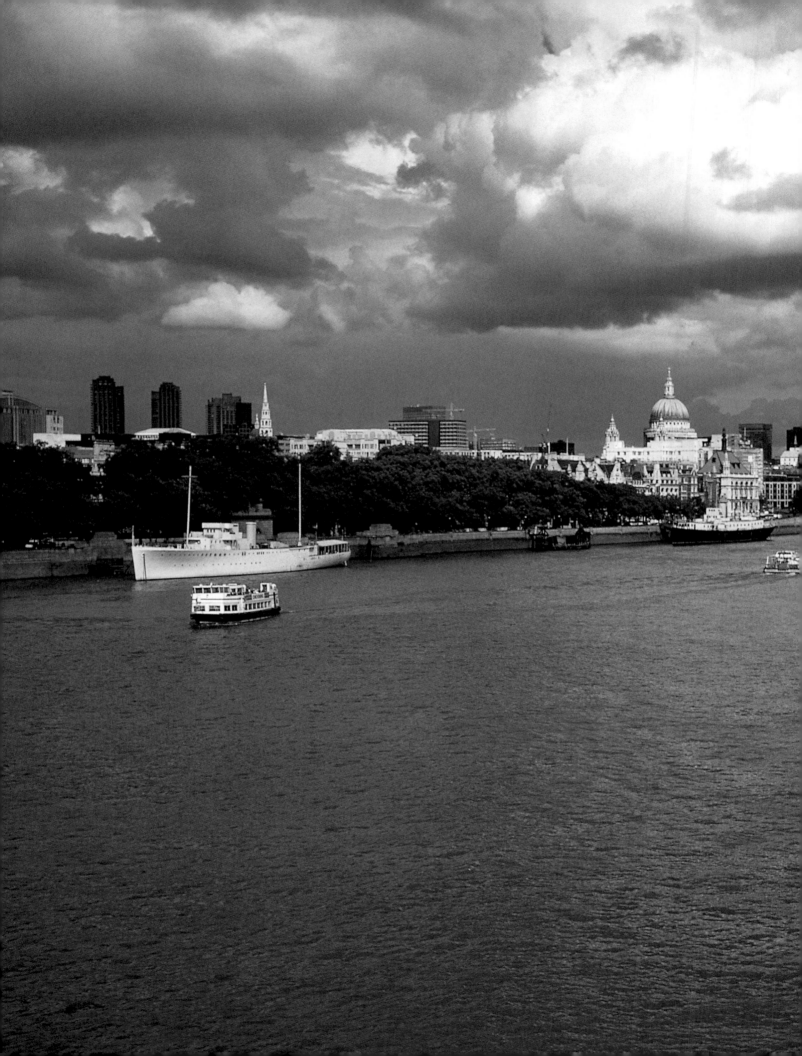

70–180mm f2.8 Apo Vario Elmarit, probably the first truly apochromatic zoom lens from any manufacturer; and the highly regarded 80–200mm f4 Vario Elmar.

Previously, Leica tended to rely on 'buying in' quality zoom designs, albeit with some re-engineering to bring them up to their own exacting standards. The new policy is a recognition that with the reflex systems a range of zoom lenses to the highest Leica optical and mechanical standards is now essential.

Generally speaking, even the very latest zoom lenses cannot provide the speed, compactness or ultimate quality of prime lenses of equivalent focal length. The exception in lens quality is the Apo Vario Elmarit, but this is at significant expense and with a considerable increase in weight and bulk.

Leica have wisely stuck with separate controls for adjusting focus and focal length. This has important benefits in terms of more robust and reliable optical and mechanical design. The 'in-house' zooms also have a constant maximum aperture at all focal lengths and very good close-focusing capability.

LENS COATINGS

Without anti-reflection coatings, it would be impossible to produce many of today's complex multi-element lenses. Reflection losses at every glass/air surface could easily halve the total light transmitted to the film plane and there would be massive loss of contrast due to flare.

Leica have been factory coating their lenses for over 50 years and during this period have led many significant developments in this field. These have been crucial to continuing improvements not only to lens performance but also to other optical components in the camera, such as viewfinder and rangefinder prisms.

For coatings to achieve maximum effectiveness, the correct material and the thickness and number of coatings for each individual lens surface to be treated have to be calculated very precisely and then applied equally precisely. The material is deposited on the untreated glass elements in a vacuum kiln, in which the appropriate metal oxides and fluorides are vaporized. The average thickness of a coating is 1/10,000mm!

Multiple coatings of different materials and thickness are applied – usually six at Leica – to achieve a 'broad band' resistance to reflections. Even in the most complex lenses with up to 20 glass/air surfaces, a light transmission efficiency of over 96 per cent can now be achieved.

Leica's latest breakthrough is the introduction of a new Ion-aided process for the deposition of the coating material. This has several advantages. Because much lower temperatures can be used in the kiln, there is much less stressing of the lens elements as they heat up and cool down again. The evenness and thickness of the coatings can be controlled even more precisely and they are also denser and harder, with better adherence to the lens surface. As well as improving performance, this adds to resistance to scratches and chemical contamination.

MECHANICAL QUALITY

No matter how brilliant the optics of a lens may be, it all counts for nothing if they are not assembled accurately in the first place, in a mount that is designed to maintain that accuracy and which is robust enough to give trouble-free service in all the arduous situations that a professional photographer is likely to meet.

Leica have never compromised on engineering quality and this applies just as much to their lenses as to their cameras. There are very many rangefinder lenses still in regular use that are over 30 years old; there are also plenty of lenses from the early days of the reflex system still performing as well as when they were new, 25 or more years ago. Some have been used to illustrate this book!

Leica fully appreciate that a lens is a photographer's working tool, and that it is their job to ensure it is built in such a way that the wonderful imaging performance of which it is capable is maintained for busy photographers who have no time to 'baby' their equipment.

Some examples of the standards that have to be met are an ability to work satisfactorily at temperatures from -20°C (-4°F) to +50°C (122°F), an auto-diaphragm mechanism that remains accurate and stops down in the required 40 milliseconds after 50,000 exposures, shock resistance to 100g and a focusing movement that remains smooth and free from stickiness and backlash for many, many years.

Compared with other manufacturers' products, Leica lenses are no lightweights. Much more metal is used in the mount construction – in particular, the focusing helicoid is usually an aluminium alloy/brass combination rather than aluminium/aluminium or polycarbonate. This is not because of any aversion to modern synthetics, but is due simply to a desire to use those materials most suitable for the required task. One example is that the silver chrome finish for some lenses in the M system requires mounts made from brass rather than the aluminium alloy of the black finish lenses. This is to ensure that a chrome finish of as high a quality as possible can be achieved.

THE AIM

The Leica lens department's aim is a very simple one: at any given time they require their lenses 'to provide top optical performance verging on the limits of the technically possible'.

Chapter 3

CURRENT LEICA M LENSES

CURRENT LEICA M LENSES

FRONT ROW, LEFT TO RIGHT: 21/2.8 ASPH, 24/2.8 ASPH, 28/2.8 ASPH, 35/1.4 ASPH, 35/2 ASPH.

SECOND ROW: 90/2, 50/1.4, 50/2, 50/1, 50/2.8.

BACK ROW: 75/1.4, 135/4, 90/2.8, 135/2.8.

Leica R8, 100/2.8 Apo Macro Elmarit, 1/4 sec at f16, Kodak T 400 CN

With the development of the extremely versatile Leica R camera system and its comprehensive programme of lenses, the range of lenses needed for the more specialized M cameras has been reduced. Compared with the R system, the M range, which runs from 21mm to 135mm, may seem somewhat restrictive, but in practice it plays very well to the M strengths. It is only in specialized areas of wildlife or sports photography, which demand very long lenses, or with critical close-up photography that the M user is inhibited. The M can, in fact, be adapted for this kind of work with the (discontinued) Visoflex add-on reflex housing and its lenses, but it has to be admitted that this is a rather clumsy solution when compared with the R8 or R6.2.

For general-purpose photography, the present M range of lenses is more than adequate, and the considerable advantages of

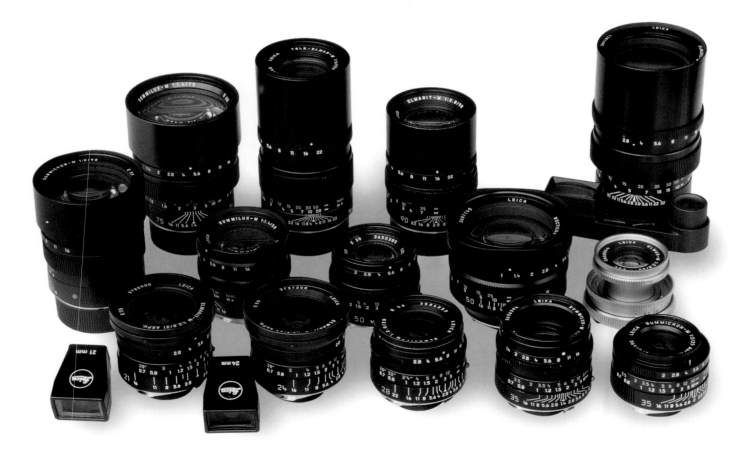

26

	CURRENT LEICA M LENSES										
Lens	Focal length (mm) maximum aperture	Angle of view degrees	Elements/groups	Smallest aperture	Focusing range	Smallest object area (mm)	Filter size	Length (mm)	Diameter (mm)	Weight (gm)	Code
ELMARIT-M ASPH *	21 f2.8	92	9/7	f16	inf–0.7m	696x1044	E55	46	58	300	11135
ELMARIT-M ASPH silver *	21 f2.8	92	9/7	f16	inf–0.7m	696x1044	E55	46	58	330	11897
ELMARIT-M ASPH *	24 f2.8	84	7/5	f16	inf–0.7m	630x945	E55	45	58	290	11878
ELMARIT-M ASPH silver *	24 f2.8	84	7/5	f16	inf–0.7m	630x945	E55	45	58	320	11898
ELMARIT-M **	28 f2.8	76	8/7	f22	inf–0.7m	533x800	E46	48	53	280	11809
SUMMILUX-M ASPH	35 f1.4	64	9/5	f16	inf–0.7m	420x630	E46	48.2	53	310	11874
SUMMILUX-M ASPH silver	35 f1.4	64	9/5	f16	inf–0.7m	420x630	E46	48.2	53	415	11883
SUMMILUX-M ASPH titanium	35 f1.4	64	9/5	f16	inf–0.7m	420x630	E46	48.2	53	415	11859
SUMMICRON-M ASPH	35 f2	64	6/6	f16	inf–0.7m	419x627	E39	34.5	53	255	11879
SUMMICRON-M ASPH silver	35 f2	64	6/6	f16	inf–0.7m	419x627	E39	34.5	53	340	11882
NOCTILUX-M ***	50 f1.0	45	7/6	f16	inf–1m	410x615	E60	62	69	630	11822
SUMMILUX-M ***	50 f1.4	45	7/5	f16	inf–0.7m	277x416	E46	46.7	54.5	275	11868
SUMMILUX-M silver ***	50 f1.4	45	7/5	f16	inf–0.7m	277x416	E46	46.7	54.5	380	11856
SUMMILUX-M titanium ***	50 f1.4	45	7/5	f16	inf–0.7m	277x416	E46	46.7	54.5	380	11869
SUMMICRON-M ***	50 f2	45	6/4	f16	inf–0.7m	277x416	E39	43.5	52	240	11826
SUMMICRON-M silver ***	50 f2	45	6/4	f16	inf–0.7m	277x416	E39	43.5	52	333	11816
ELMAR-M	50 f2.8	45	4/3	f16	inf–0.7m	277x416	E39	37.6	52	170	11831
ELMAR-M silver	50 f2.8	45	4/3	f16	inf–0.7m	277x416	E39	37.6	52	245	11823
SUMMILUX-M ***	75 f1.4	31	7/5	f16	inf–0.75m	192x288	E67	80	68	560	11810
APO-SUMMICRON-M ASPH ***	90 f2	27	5/5	f16	inf–1m	220x330	E55	78	64	520	11884
ELMARIT-M ***	90 f2.8	27	4/4	f22	inf–1m	220x330	E46	76	56.5	410	11807
ELMARIT-M silver ***	90 f2.8	27	4/4	f22	inf–1m	220x330	E46	76	56.5	620	11808
ELMARIT-M titanium ***	90 f2.8	27	4/4	f22	inf–1m	220x330	E46	76	56.5	620	11899
APO-TELYT-M ***	135 f3.4	18	5/4	f22	inf–1.5m	220x330	E49	106	58.5	550	11889
TRI-ELMAR-M ASPH ***	28/35/50 f4	76/64/45	8/6	f22	inf–1m	28=750x1130 35=620x930 50=430x650	E55	70	58	340	11890

* Additional viewfinder required ** Additional viewfinder required for M6/0.85 and M4-2 and earlier

*** These lenses have a built-in lens hood – others are supplied with a separate hood

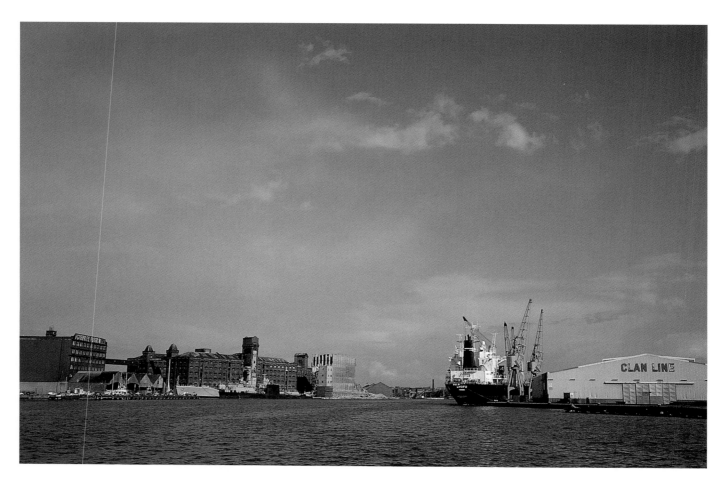

the rangefinder camera in areas such as low-light photography, photojournalism and travel are supported by outstandingly good optics. In particular, Leica have developed some very fast, top quality lenses for the M. The 50mm f1 Noctilux and the 35mm f1.4 Summilux ASPH are remarkable examples of the lens maker's art, specially designed to exploit the M cameras' abilities in 'available darkness'. The 35mm f2 Summicron ASPH is the latest and greatest development of a classic lens in a remarkably compact package, complementing perfectly the compact dimensions of the M camera. Compared with a single-lens reflex, the rangefinder system offers significant advantages to lens designers. Optically, they are free of the need to produce lenses with sufficient back focus to ensure that the rear element is clear of the reflex camera's instant return mirror. With wide angle lenses especially, this constraint imposed by an SLR can be quite serious.

Mechanically, too, the M lens is free of the cams and levers for fully automatic diaphragms and full aperture metering systems that an SLR lens needs. In design terms, the essential rangefinder cam is relatively simple to incorporate, although it does require extreme precision in manufacture, assembly and final adjustment of the lens. The rangefinder lenses can therefore be made very robust and relatively compact. The

BIRKENHEAD DOCKS, ENGLAND

The range of focal lengths available for the rangefinder M cameras is much more limited than for the reflex system. Nevertheless, as can be seen here, the range even from the popular 35mm to the longest 135mm is considerable.
Leica M6, 35/2 Summicron, 1/250 sec at f5.6, 135/4 Tele-Elmar 1/500 sec at f4, Kodachrome 25 Professional

reliability factor achieved with quality manufacturing is easily judged by the number of M lenses from the 1960s and 1970s that are still in regular use, and the fact that lenses from way back in the 1930s will still couple accurately with a modern M6 rangefinder and deliver very acceptable results.

RANGEFINDER/ VIEWFINDER

The standard M6 range viewfinder has brightline viewing frames for 28mm, 35mm, 50mm, 75mm, 90mm and 135mm focal lengths. For the 21mm and 24mm lenses, a separate viewfinder is fitted to the accessory shoe. The viewfinder magnification is a constant 0.72x life size. Compared with a typical SLR, this means that the M viewfinder image is about the same size when a 50mm lens is fitted, larger when wide

angle lenses are fitted, but smaller with the longer focal lengths. The focusing accuracy with the rangefinder, which is related to its base length and the magnification, is also constant, irrespective of the focal length or maximum aperture of the lens fitted.

Any user of an SLR knows that with reflex focusing both these factors affect accuracy significantly. It is generally accepted that the 'break-even' point for the two systems is around the 90mm focal length. This means that with wide angle lenses the M rangefinder is several times more accurate, while with focal lengths longer than this the SLR becomes increasingly superior. In fact, 135mm has long been accepted as the longest lens that can be focused reliably with the M rangefinder. The frames for the different focal lengths can be previewed by moving the lever on the front left of the camera, thereby allowing the most suitable lens to be chosen easily.

STANDARD LENSES

The 'standard' focal length of 50mm is a good general-purpose lens as it equates with the angle of view of the human eye. There are four 50mm lenses available for the M6. Each has advantages and disadvantages and no particular one can be described as the best, as this will depend very much on the individual photographer's needs.

50MM F2 SUMMICRON-M

When the first 50mm Summicron was announced for the Leica IIIf in 1953, it was a sensation. It incorporated new types of optical glass and the design set new standards for lenses for 35mm cameras. The second version was introduced in 1958, when a completely revised optical design – which nevertheless retained seven elements – was set in a rigid rather than a collapsible mount. The third version appeared in 1968, when new glass types allowed a six-element design with closer focusing (0.7m/28in instead of 1m/40in) and better correction in the near range. The current, fourth, version was designed and first produced by Leica Canada in 1978. It also has six elements but with even more advanced glass types and is of lighter construction than its predecessor. The lens was modified in 1994 to incorporate a built-in lens hood but the optical design remains unchanged. Each of these four Summicrons has become the standard for judging all other contemporary 50mm lenses for 35mm cameras.

Not surprisingly, the Summicron is the most popular standard lens. The maximum aperture of f2 is entirely adequate for most needs, it focuses closer than the Noctilux (0.7m/28in instead of 1m/40in) and it is smaller, lighter and cheaper! Partly because of its more modest maximum aperture, a higher degree of correction for the various optical aberrations has also been achieved and this is maintained throughout its full focusing range. In absolute technical performance this is the best of the

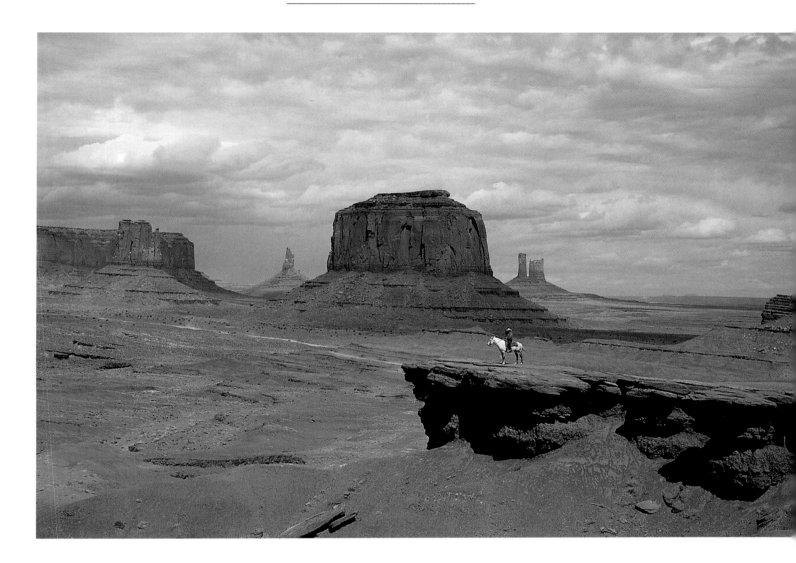

MONUMENT VALLEY, USA

The Summicron has always been one of the finest 50mm lenses around. The latest version with built-in lens hood is even more convenient.

Leica M6, 50/2 Summicron, 1/125 sec at f4, Kodachrome 25 Professional

four standard lenses, and if this were the only factor to be taken into account this lens would have to be the first choice. It is available in silver chrome as well as the standard black finish, but the chrome lens is heavier as this finish requires that the lens mount is made from brass instead of light alloy.

50MM F1.4 SUMMILUX-M

Although, superficially, a relatively old design, this lens seems to have been 'tweaked' over the years – the coatings in particular have been improved to give very good colour rendering. This lens has always been especially reliable when shooting against the light, with great freedom from reflections and flare. Performance at f1.4 is remarkably good. A careful comparison would show the Summicron to have better edge definition at f2 and f2.8, but from f4 to f16 you would have great difficulty distinguishing between them on any normal subject. The Summilux is slightly bulkier and noticeably heavier than the Summicron, but it is still quite compact and fits easily into an

outfit case. It is comfortable to handle and the less steep focusing helix can sometimes make for greater accuracy. The latest version has a built-in lens hood, takes 46mm filters and focuses to 0.7m (28in). It is available in silver chrome and titanium finish as well as black, but again with a weight penalty.

50MM F1 NOCTILUX-M

This lens is a technical *tour de force*. Image quality at f1 is very good over most of the field, and remarkably free from reflections and flare caused by bright lights in the picture area. Although the design has naturally been optimized for low-light photography at the wider apertures, the lens still performs very well indeed for more normal photographic applications in good light at smaller stops. All lenses are subject to vignetting (darkening in the corners) at wider apertures and wide angles:

TOKYO STATION
These two train cleaners were waiting for the first-class passengers to disembark from one of the famous 'bullet' trains. Light levels in the station were low. The extra speed of a Summilux can sometimes be very valuable for travel photography.
Leica M6, 50/1.4 Summilux, 1/60 sec at f2, Kodachrome 200 Professional

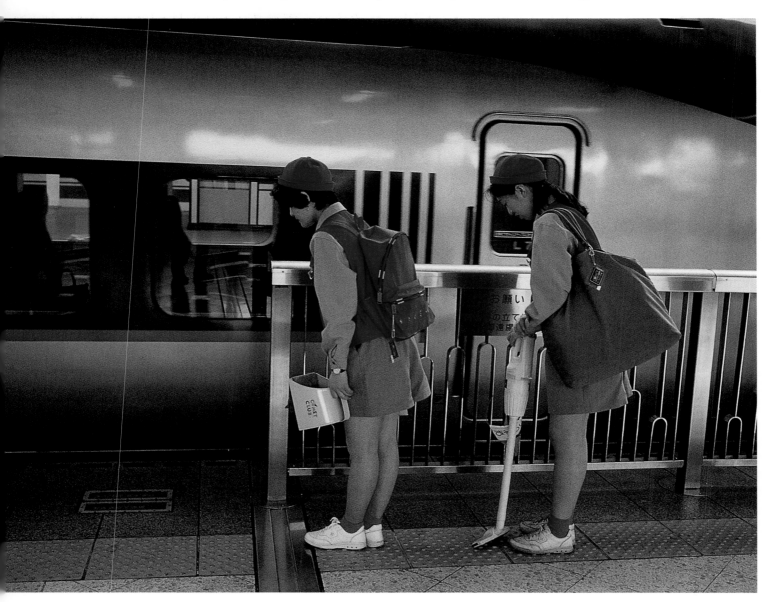

open up any f2 lens to its maximum aperture and photograph an even tone, such as a white wall or blue sky, and this will be apparent. Not surprisingly, at the Noctilux's f1 maximum this vignetting is more obvious, but in practice this is rarely a problem with the kind of pictures taken in very low light. The lens is big and heavy as well as extremely expensive, but if you habitually work in poor light the performance is astonishing, with outstanding differentiation of tonal values and colour. The current lens, introduced in 1994, has a redesigned mount incorporating a built-in lens hood but the optical design is identical to its predecessor.

50MM F2.8 ELMAR-M

This lens is a completely redesigned version of an old favourite. The lightweight collapsible design allows a truly pocketable camera. Performance is very good at f2.8, excellent when stopped down. It is particularly free from flare. Black or silver chrome.

WIDE ANGLE LENSES

The 35mm focal length is a classic lens for the street photographer or photojournalist as well as for much travel photography. In practice, many such photographers look upon the 35mm as their standard lens. This was why the later M2 viewfinder, which incorporated a 35mm frame as standard, eventually overtook the M3 and became the basis for subsequent M cameras. More recently, the 28mm has become very popular and Leica have 'stretched' the finder to include this frame also. The 21mm and 24mm lenses are more specialized in application, so that the need to use a separate viewfinder for these focal lengths is less inconvenient than might be expected. The 28mm and, even more so, the 24mm and 21mm lenses can provide dramatic perspective effects and great depth of field, so that dominant foregrounds can be set against detailed, still sharp backgrounds.

All the wide angle M lenses are supplied with efficient, specially designed rectangular lens hoods, complete with a soft material lens cap that clips on to the hood so that it can be left on the lens if so desired.

21MM F2.8 ELMARIT-M ASPH

This lens was introduced in 1997. It represents an important application of Leica's aspheric lens technology, which has resulted in a lens that must be a class leader in the super wide angle category. Performance is remarkable at full aperture, by f5.6 it is quite outstanding, and by this stop too the inevitable vignetting of such a wide angle lens is reduced to the theoretical minimum. Like its predecessor, the lens is relatively free from reflections, which is useful – as when shooting against the light – the sun is quite likely to be included in the wide picture area.

FOLLOWING PAGES
NEW YORK FROM THE STATEN ISLAND FERRY
The 28mm is the widest lens for which the M6 has a built-in viewfinder frame. A cold, clear November day provided ideal light for this shot of one of my favourite views.
Leica M6, 28/2.8 Elmarit, 1/125 sec at f5.6, Kodachrome 25 Professional

Distortion is barely detectable – remarkable in such a wide angle lens. The lens is more compact than its predecessor and uses the more conveniently available 55mm filter size.

24MM F2.8 ELMARIT-M ASPH

A new focal length for the M system, responding to a repeated demand from photojournalists. As might be expected with the aspheric design, the overall performance is excellent. First-class results are available at full aperture, and by f5.6 the lens is outstanding at all focus distances and free of artificial vignetting. Distortion (very slight barrel) is minimal and most unlikely to be noticed in normal use.

28MM F2.8 ELMARIT-M

A new design introduced in 1993. This latest version is a significant improvement and noticeably more compact than its predecessor. First-class performance at full aperture improves slightly on stopping down to f4/f5.6. Reflections from bright light sources in the picture are well controlled, and for practical purposes distortion is non-existent. This is a highly desirable lens.

35MM F1.4 SUMMILUX-M ASPH

Introduced in 1994, this was the first of Leica's ASPH series of M lenses, where the aspheric element is manufactured with Leica's new *blanken-presse* technology. It replaced the limited production 35mm f1.4 aspherical, which incorporated two aspheric elements produced by earlier, much more costly processes. Performance of the ASPH lens is fully comparable with its very highly regarded and much more expensive predecessor. The excellent image performance at f1.4, especially near the edges, improves very slightly on stopping down. Distortion is minimal and it is very good against the light, being relatively free from reflections. Vignetting is low for such a wide aperture lens and controlled by f4. Available in black, silver chrome and titanium finishes.

35MM F2 SUMMICRON-M ASPH

The 35mm Summicron has always been one of the key lenses in the Leica M system. This new ASPH design, introduced in 1997, is the fifth generation and a more than worthy successor to its predecessors. Although it is slightly less compact than the model immediately prior, the application of ASPH technology has produced an absolutely outstanding lens. Full aperture performance is very good indeed and by f5.6 it reaches the very highest levels. The inevitable full aperture vignetting has been significantly reduced with the new design and is controlled by f4.

This lens will enhance the reputation of the 35mm Summicron as the classic lens for the Leica M cameras. It is available in black and silver chrome, the latter being heavier due to the need for brass instead of light alloy for the mount.

SPIDER ROCK, CANYON DE CHELLY, ARIZONA, USA
Although it does not feature an aspheric element, this latest '28' is a superb lens and was the ideal focal length for this view.
Leica M6, 28/2.8 Elmarit, 1/125 sec at f5.6, Kodachrome 25 Professional

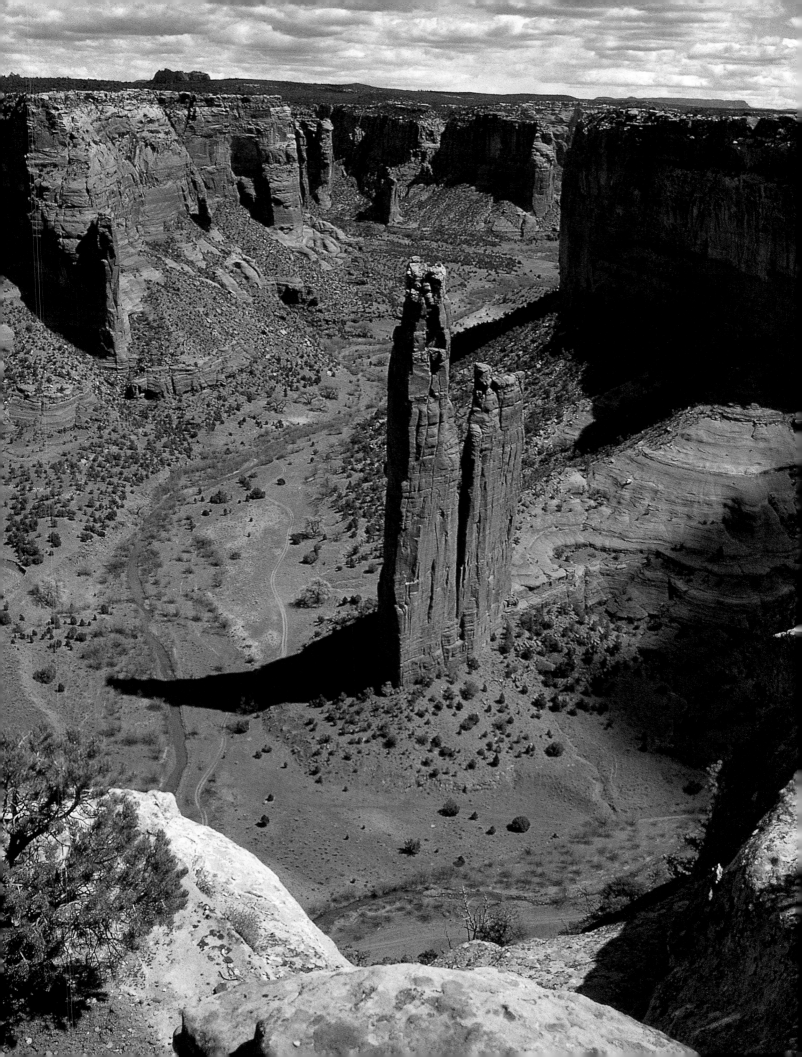

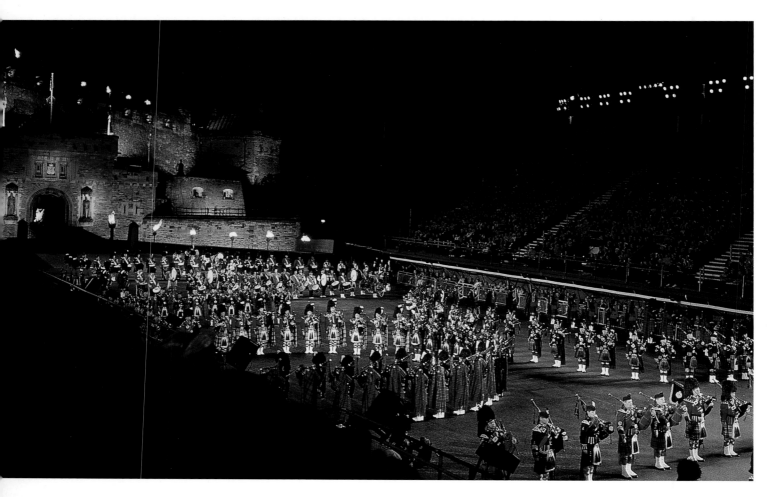

THE EDINBURGH TATTOO

This spectacular Scottish event needs fast lenses and fast film to record it. Here the 35mm f2 ASPH shows its abilities at full aperture.
Leica M6, 35/2 Summicron ASPH, 1/125 sec at f2, Kodachrome 200 Professional

TELEPHOTO LENSES

Strictly, the word 'telephoto' means a lens with shorter back focus than its focal length, but the term is now generally used to include any lens with a focal length longer than standard.

Leica provide three focal lengths in the range of longer lenses for the M series. These are 75mm, 90mm and 135mm, with a choice of maximum aperture for 90mm. All but the 75mm are of true telephoto construction, enabling the design to be kept very compact. Apart from the obvious advantage of allowing less accessible subjects to be photographed, the benefits of a medium telephoto such as the 75mm or 90mm are that they encourage selectivity of subject matter and, because of the reduced depth of field available, allow differential focusing so that a sharp main subject is separated from an out-of-focus background. The 135mm focal length is a very useful longer telephoto for travel, landscape and some general-purpose sports and action photography, but those specializing in wildlife and sport photography will probably also wish to have longer focal lengths available with the Leica R system.

75MM F1.4 SUMMILUX-M

When a longer focal length with an f1.4 maximum aperture was required, this was the longest that could be accommodated without seriously obscuring the viewfinder. This is a first-class lens, particularly free from reflections and with good performance wide open at f1.4, which becomes excellent at f4 and smaller stops.

90MM F2 APO-SUMMICRON-M ASPH

An outstanding new lens bringing the benefits of Leica's aspheric technology to the medium telephoto range. This has enabled apochromatic correction so that the lens performs superbly at all apertures and throughout the focusing range. It is

ST MARK'S, VENICE
The 90mm is an important focal length, ideal for portraits or selecting details such as this.
Leica M6, 90/2 Summicron, 1/250 sec at f4/5.6, Kodachrome 25 Professional

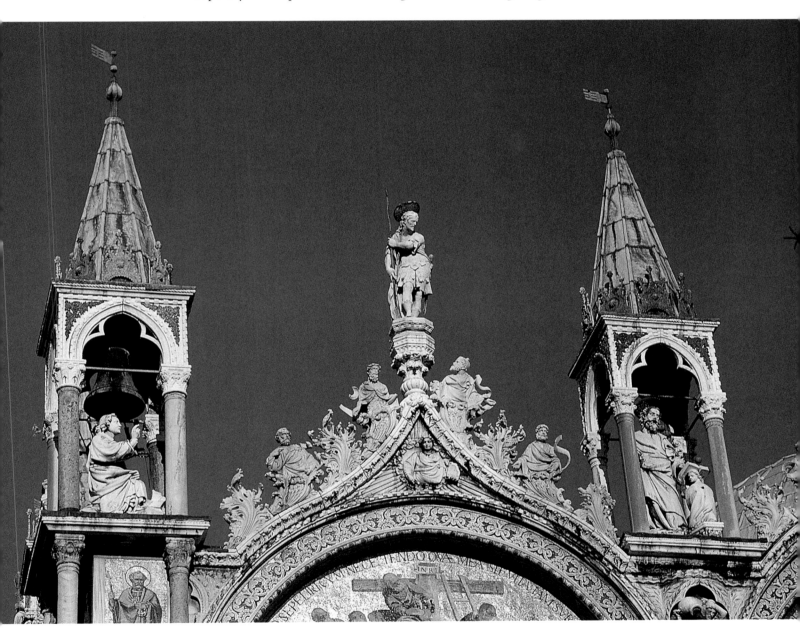

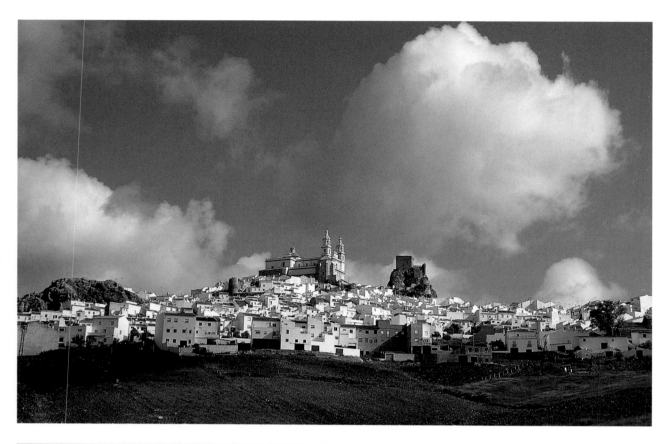

SCHLOSS HOHENSCHWANGAU, BAVARIA

The narrower angle of the 90mm enabled me to concentrate on the castle and to eliminate a grey sky.
Leica M6, 90/2 Summicron, 1/250 sec at f4, Kodachrome 25 Professional

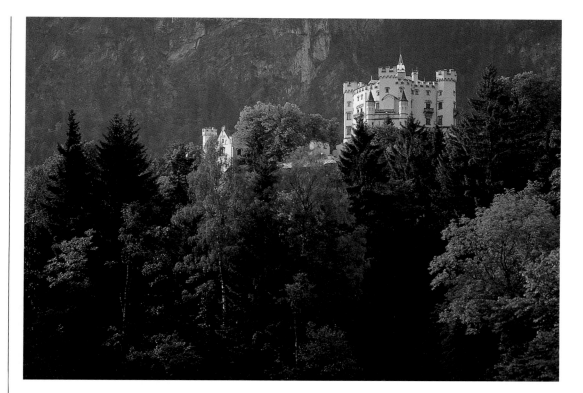

virtually the same size and weight as its predecessor and therefore very compact and portable.

90MM F2.8 ELMARIT-M

The same optical design as the 90mm f2.8 Elmarit-R – a well tried lens of excellent performance at all apertures. It is a little more compact than the 90mm Summicron but not markedly so. Performance in the near range is a little better than the Summicron. This lens is very keenly priced and this, plus top optical performance, makes it a very good buy.

135MM 3.4 APO–TELYT-M

This lens replaces both the 135/2.8 Elmarit-M and the 134/4 Tele-Elmar-M. As would be expected from the Apo designation this is another outstanding performer. It is only a little bigger and heavier than the Tele-Elmar bringing more speed and even a higher performance in a compact package which is ideally suited to the M cameras. The new higher magnification (0.85) finder is an advantage when using this focal length.

OLVERA, ANDALUCIA, SPAIN

One of the pretty white towns allied to a wonderful sky made a great subject for my new Tri-Elmar. The shots were taken at the 28mm and 50mm settings to show the range available with this lens which is an ideal companion for those wishing to travel light with an 'M'.
F4 Tri-Elmar-M ASPH, 1/125 sec at f5.6, Kodachrome 25 Professional

MULTI FOCAL LENGTH

Zoom lenses have long been available for reflex cameras but the mechanical and optical problems associated with the range-finder coupling as well as providing a satisfactory viewfinder image have, until now, precluded anything similar for the M series cameras. Leica design and production technology has triumphed with the introduction of the Tri-Elmar.

LIZARD, ARIZONA
The 'M' is not the ideal camera for wildlife or close-up photography, but in this case the longest rangefinder focal length gave me a reasonable image of this little chap.
Leica M6, 135/4 Tele-Elmar, 1/500 sec at f8, Kodachrome 200 Professional

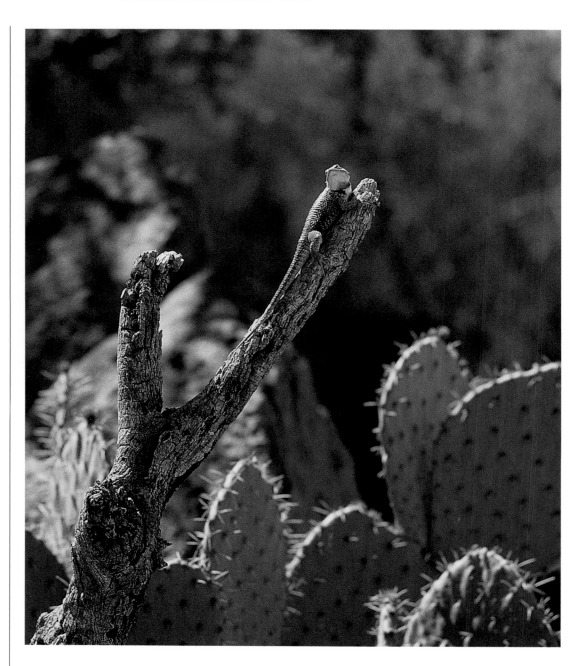

28-35-50MM F4 TRI-ELMAR-M ASPH

This lens is a remarkable achievement that will appeal to those such as walkers, climbers, travel photographers and others who wish to carry the minimum equipment within the tough reliable M system. One lens covers the most popular focal lengths from wide-angle to standard. While the maximum f4 aperture is a little slow, performance is very good wide open and reaches its optimum between f5.6 and f8. This is perfectly adequate for many subjects and the lens offers great convenience. It is not a zoom: the focal length settings go 28, 50, 35 to fit in with the sequencing of the 'M' brightline frames, so that intermediate settings are not possible.

CROSS-SECTION DIAGRAMS OF CURRENT LEICA M LENSES

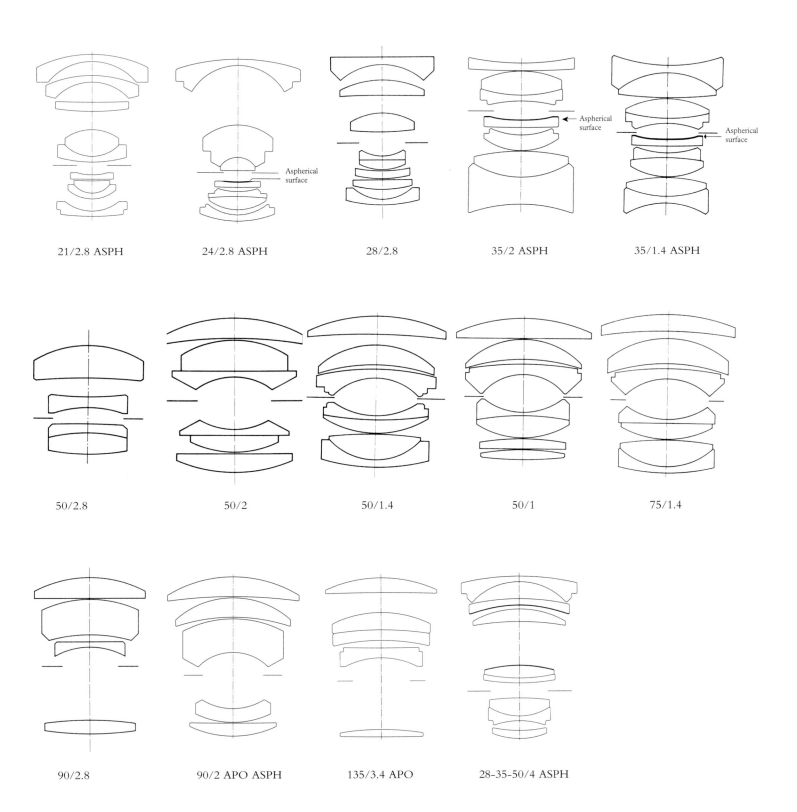

21/2.8 ASPH 24/2.8 ASPH 28/2.8 35/2 ASPH 35/1.4 ASPH

50/2.8 50/2 50/1.4 50/1 75/1.4

90/2.8 90/2 APO ASPH 135/3.4 APO 28-35-50/4 ASPH

Chapter 4

CURRENT LEICA R LENSES

ULLSWATER, CUMBRIA, ENGLAND
By keeping the horizon in the middle of the frame I was able to avoid any curvature, so there is no obvious fisheye distortion.
Leica R4, 16/2.8 Fisheye Elmarit, 1/60 sec at f5.6, Kodachrome 25 Professional

The lenses for the R system are inevitably bigger and heavier than their M equivalents. The mechanical demands of auto diaphragms, a larger camera throat size to accommodate the reflex mirror and the requirements of wide aperture, long focal length lenses, as well as the new electronic connections, all have a consequence. As previously indicated, too, the engineering standards set by Leica are geared to long-term reliability and impact resistance rather than light weight!

Compared with the M lenses, the range is much greater. This reflects the greater versatility of the reflex system, especially in such areas as close-up and long telephoto applications, as well as specialist needs such as architecture.

Focal lengths available run from 15mm to 800mm and there are two excellent extenders available that add significantly to the flexibility of the system. In popular focal lengths there is a

44

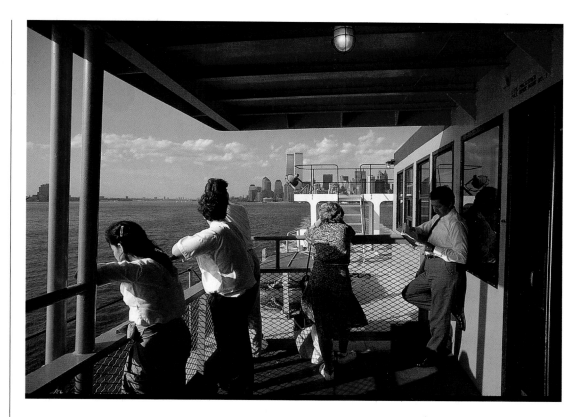

choice of apertures. There is also now a range of excellent zoom lenses. All the R lenses have the classic Leica characteristics of subtle tonal and colour differentiation, luminosity and full aperture performance that can confidently be relied upon.

STANDARD LENSES

Lenses around 50mm or 60mm focal length are considered standard because they approximate to the angle of view of the human eye. Although within reflex systems their role has tended to be taken over by 'mid-range' zooms, they can still be very useful for low–light work needing high quality at very wide apertures or for superior macro performance.

50MM F2 SUMMICRON
Well established as an outstanding performer. Very reasonably priced, and the standard lens of choice unless you really need the extra stop of the Summilux or the ultra close focusing of the Macro Elmarit.

50MM F1.4 SUMMILUX-R
A completely new design showing significant improvement compared with its predecessor. Slightly bigger and heavier than the Summicron – and more expensive! Performance is very good at f1.4 and becomes excellent by f2.8.

60MM F2.8 MACRO ELMARIT

Focusing down to half life size unaided, or life size with the Macro Adapter. High quality and a perfectly flat field (essential for copying work) are maintained throughout the entire focusing range. A very versatile alternative to the Summicron or Summilux.

MEDIUM WIDE ANGLE: 28MM AND 35MM FOCAL LENGTHS

Many photographers use the 28mm or 35mm focal lengths extensively. For many popular applications – such as landscape, photojournalism or industrial photography – one or the other is an essential tool, so a high-quality prime lens in this range is highly desirable.

28MM F2.8 ELMARIT

A fairly recent (1994) redesign of an old favourite. Excellent performance is achieved with the use of floating elements. Other improvements over its predecessor include a built-in lens hood and a more practical filter size (E55 screw-in). Inevitably, with such wide angles there is some vignetting at full aperture but this is minimal, not noticeable in most circumstances and in any case for all practical purposes can be eliminated by stopping down below f5.6.

LEICA R WIDE ANGLE LENSES

FRONT ROW, LEFT TO RIGHT: 16/2.8, 19/2.8, 24/2.8, 28/2.8.

BACK ROW: 15/3.5, 35/1.4, 35/2, 28/2.8 PC.

Leica R8, 100/2.8 Apo Macro Elmarit, 1/4 sec at f16, Kodak T 400 CN

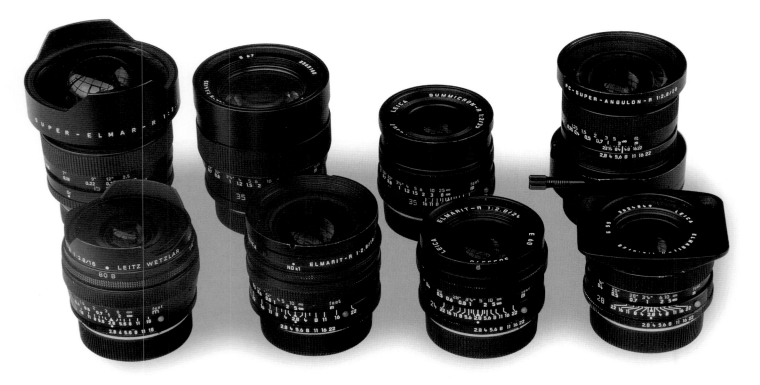

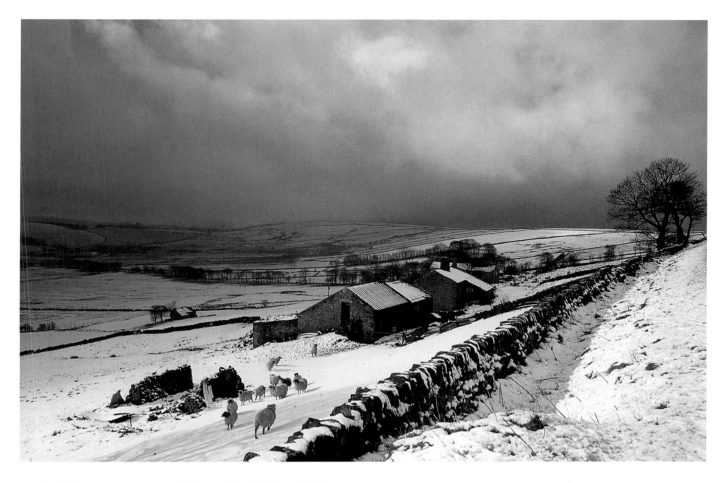

WINTER IN DERBYSHIRE, ENGLAND
The latest version of the 28mm Elmarit features a built-in lens hood and the more convenient 55mm filter size – helpful when fumbling on a bitterly cold day.
Leica R7, 28/2.8 Elmarit, 1/250 sec at f5.6/8, Fuji Provia 100

35MM F2 SUMMICRON
A well-tried favourite. First–class quality wide open at f2, superb when stopped down only slightly. There is practically no distortion and the level of vignetting even at full aperture is particularly low for such a high-speed wide angle. Care is sometimes needed to avoid flare when very bright highlights (such as the sun) are included in the picture area or are just outside it.

35MM F1.4 SUMMILUX-R
The 1 stop increase in speed results in a very much longer and heavier lens, but at stops below f1.4 performance is comparable with the Summicron. There is slightly more vignetting apparent at f1.4 and extremely slight barrel distortion.

28MM F2.8 PC SUPER ANGULON-R
Produced by Joseph Schneider to Leica requirements, this is an outstanding perspective control lens. It is ideal for architectural photography and studio product and still-life shots, where correction of converging or diverging verticals is necessary. With no shift applied, central definition at full aperture is excellent and edge definition is good. When the maximum shift of 11mm is applied, stopping down to f8 or f11 is needed for

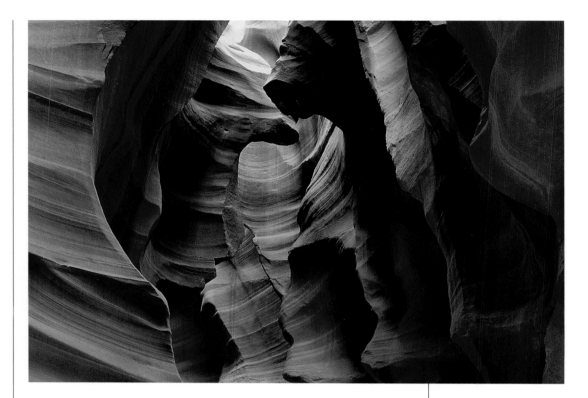

best edge detail. There is no automatic diaphragm and after focusing at full aperture the lens needs to be stopped down manually to the working aperture. Exposure metering must also be at the working aperture when the camera is in manual mode. The lens cannot be used in shutter priority or programme modes.

ULTRA WIDE ANGLE LENSES: 15–24MM FOCAL LENGTHS

As well as being able to include more of the subject area from a given viewpoint, the ultra wide angle lenses offer great opportunities for dramatic perspective effects, allowing monumental foreground objects while still including all the relevant background. Depth of field too is tremendous, so that foreground and background can easily be kept in suitably sharp focus.

15MM F3.5 SUPER ELMAR-R

This lens is based on a very successful Zeiss design with floating elements. It is very big and heavy but produces a first-class rectilinear (non-fisheye) image over the full fields – even at f2.8 the quality is remarkable. For such a wide angle (110 degrees) the level of vignetting is very low. Filters are built in – UVa, yellow, orange and blue.

16MM F2.8 FISHEYE ELMARIT-R

This is basically a Minolta lens re-engineered to Leica standards. One of the best fisheye lenses around, it gives a full-frame image, not the circular picture that some fisheye lenses produce. The 180 degree angle of view allows for some quite remarkable effects and the quality even at full apertures is very good. Also with built-in filters – UVa, orange, yellow and blue.

19MM F2.8 ELMARIT-R

An absolutely superb lens. Introduced at Photokina in 1992, it represented a significant improvement optically on its predecessor – itself a very good lens – as well as being more compact. It is even better than the now discontinued 21mm f4 Super Angulon, an outstanding lens and the favourite super wide of many photographers (author included!). First-class performance at full aperture improves slightly on stopping down. Features floating elements and built-in ND 1X blue, orange and yellow filters.

ZION, UTAH, USA
A wonderful autumn morning. The '19' was wide enough to capture the whole scene and performed remarkably when shooting into the light.
Leica R8, 19/2.8 Elmarit, 1/125 sec at f5.6, Kodachrome 25 Professional

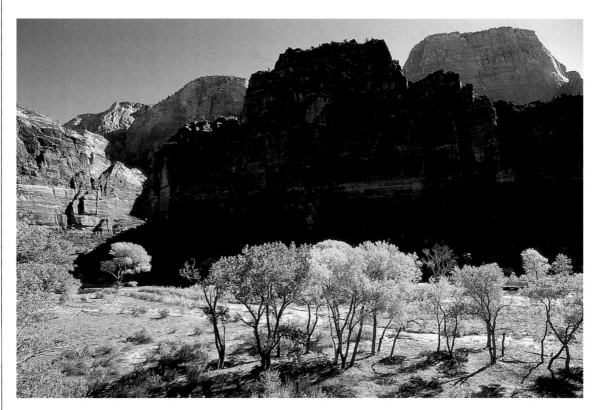

24MM F2.8 ELMARIT-R

This focal length is very popular as it gives a good wide angle of view without the steep perspective effects of the even wider lenses. Minolta optical and Leica mechanical design with floating elements give a very good-quality image at full aperture, with some improvement on stopping down. Some vignetting at full aperture can be practically eliminated when stopping down a little.

MID-RANGE TELEPHOTOS: 80–180MM FOCAL LENGTH

A medium telephoto can be one of the most useful lenses in any outfit. One of the 80mm, 90mm or 100mm lenses makes an ideal companion to a 28mm or 35mm Summicron – the wide angle can be used to set the scene while the short tele concentrates on essentials. It is also ideal for head-and-shoulder portraits with natural perspective. The longer 135mm or 180mm focal lengths allow greater reach and are excellent for photojournalism, sports photography and some wildlife, and begin to show the compressed perspective of the longer telephotos.

80MM F1.4 SUMMILUX-R

A very fast lens, its good performance wide open becomes very good on stopping down a little. For best results it also needs stopping down in the near range (say, closer than 1.5m/5ft). Remarkably free from reflections when bright light sources are included in the frame. This and the high speed make it a good choice for street scenes at night or theatre photography. Very good differentiation of subtle colour nuances.

90MM F2 SUMMICRON-R

Although this is now a relatively old (1968) design, improvements in coatings and other minor changes have ensured that this lens is still in the forefront for its speed and

LEICA R LENSES 50mm TO 180mm

FRONT ROW: 80/1.4, 50/1.4, 60/2.8, 50/2.

SECOND ROW: 180/2, 135/2.8, 100/2.8, 90/2.

BACK ROW: 180/2.8, 180/3.4.

Leica R8, 100/2.8 Apo Macro Elmarit, 1/4 sec at f16, Kodak T 400 CN

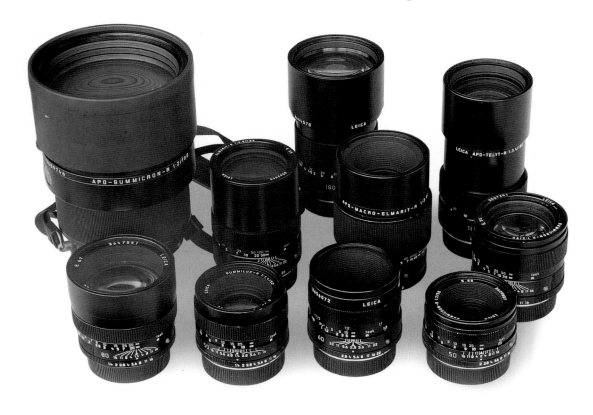

ELIZABETH
For portraits, the fast 90mm gives nice perspective and the ability to keep an obtrusive background out of focus by using a fairly wide aperture.
Leica RE, 90/2 Summicron, 1/250 sec at f4, Kodachrome 25 Professional

NUMBER 3
A medium telephoto was ideal for this fairly close shot taken from the inside of a bend. A fairly slow shutter speed kept the car reasonably sharp but allowed the panning effect to retain an impression of speed.
Leica R4, 90/2 Summicron, 1/60 sec at f5.6, Kodachrome 64

BRYCE CANYON, UTAH, USA

As well as being ideal for close-ups, the 100mm Apo Macro is an outstanding general-purpose lens.

Leica RE, 100/2.8 Apo Macro Elmarit, 1/500 sec at f5.6, Ektachrome 100 SW

focal length. Can confidently be used at full aperture, where performance is already very good over the whole field even in the near range. Stopping down only 1 or 2 stops further brings the image quality into the excellent class. With the Elpro 3, high-quality close-ups with ratios as high as 1:3 can be achieved. A classic lens, highly recommended.

90MM F2.8 ELMARIT-R

One stop slower and slightly smaller and lighter than the 90mm Summicron. Performance is very close but not quite equal to the faster lenses, although it is equally good with the Elpro. A worthwhile alternative when cost is a factor.

100MM F2.8 APO MACRO ELMARIT-R

Widely acclaimed as one of Leica's best-ever lenses in both the near and far focusing ranges. Performance at full aperture is first class; stopped down, it is stunning. It is heavier and bulkier than the 80mm and 90mm lenses, but if this, or a requirement for a wide maximum aperture, or cost, are not so important, the performance and versatility of this lens make it a first-class choice. The lens itself focuses to half life size (1:2). Closer focus requires its own special Elpro, which then allows an image slightly larger than life size (1.1:1).

100MM F4 MACRO ELMAR

This lens is supplied in a short mount for the focusing Bellows BR2. With the latter combination, focusing is possible from infinity to 1.1:1. This is a first-class combination for the dedicated close-up worker. The lens quality is excellent at all apertures, with a very flat field and no distortion.

135MM F2.8 ELMARIT-R

At one time 135mm was one of the most popular longer focal lengths for reflex cameras, but the tendency now is to go for a 180mm or a mid-range zoom such as the 80–200mm Elmar. Nevertheless, this is a first-class lens, compact for its focal length and delivering very good image quality at f2.8 – and even better when stopped down a little.

180MM F2 APO SUMMICRON-R

As one might expect, a lens of this speed with this focal length is huge and heavy. If you have the strength to carry it and the money to pay for it, it is a superlative performer even at its full aperture of f2.

180MM F2.8 APO-ELMARIT-R

This lens has replaced the popular 180mm Elmarit-R and the remarkable 180mm f3.4 Apo-Telyt-R. It combines and improves upon the best of both these excellent lenses. Outstanding performance is already available at the full aperture of f2.8 and it also very good in the close-up range. A compact design with excellent handling helped by the internal focusing.

53

PARAGLIDING

The 280mm f2.8 lens head can be used with three different focusing modules to give a 280mm f2.8, 400mm f4 or 560mm f5.6 combination.

Leica R8, 280/2.8 Apo Telyt, 1/1000 sec at f4/5.6, Ektachrome 100 SW

LONGER TELEPHOTOS: OVER 180MM

For applications requiring focal lengths in excess of 180mm, the Leica R programme provides prime lenses from 280mm to 800mm. Choice within this range has to be related much more precisely to the photographer's personal requirements than in any other group. An extra stop or two of speed adds enormously to size, weight and cost. There is no doubting the fascination of the long lens image, and for sport and wildlife photography these lenses are essential. Nevertheless, my advice to non-specialist photographers is to consider their needs very carefully: it may well be that a 180mm plus a 2x Apo Extender will be a better solution for occasional use. If at all possible, actually handle the different lenses – focusing and a comfortable hold to help avoid camera shake are vital for sharp results. Leica have put considerable effort into the ergonomics of these long lenses, but personal preferences and handling techniques vary considerably so a practical test of the camera/lens combination in mind is very desirable.

With the introduction of the Apo Module system, Leica have rationalized their range of prime lenses beyond 180mm. A

system of two lens heads and three focusing modules now provides six combinations of focal length and lens speed. Of the earlier long telephoto lenses, only the 280mm f4 has been retained.

280MM F4 APO TELYT

A lens of outstanding performance, considered by the Leica optical design team to be one of their very best achievements. There is no distortion, and maximum image quality is available at full aperture as well as in the close-focusing range. Half the weight of the earlier 280mm f2.8 and considerably more compact, it can be hand held comfortably. The lens works extremely well with the 1.4x and 2x extenders, thereby providing a 400mm f5.6 and 560mm f8. Unless you really need the wider apertures available with the Apo Telyt-R Module system, this lens is highly recommended.

APO TELYT-R MODULE SYSTEM 280MM F2.8 TO 800mm F5.6

The Apo Module system is intended primarily for professional sports and wildlife photographers, and others who require a range of fast, long telephoto lenses for their work.

Two different lens heads (280mm f2.8 and 400mm f2.8) can be combined with any of three focus modules, giving

APO MODULE SYSTEM

The Apo Module system consists of two lens heads and three focusing modules, offering a choice of optics for sports and wildlife photography.

Photo Leica Archiv

respectively 280mm f2.8, 400mm f4, 560mm f5.6 and 400mm f2.8, 560mm f4, 800mm f5.6. Each combination provides full Apo correction with outstanding contrast and detail rendering. Top performance is available at full aperture and there is only marginal improvement on stopping down. Full imaging quality is also maintained in the close-focusing range. Each combination can also be used with the 1.4x and 2x Apo Extenders. With these, stopping down by one or two values may be necessary if critical detail is present in the corners of the picture.

The Apo Module system is beautifully engineered for easy assembly. There is a quick, reliable bayonet mount system for attaching the lens head to the focus module. Each lens head has a tripod mount, with both ¼in and ⅜in threads, the mount is rotatable for either landscape or portrait format, and there is also a carrying handle that incorporates a sighting device to facilitate initial aiming at a subject. Due to their size and weight, these lenses are best worked from a good tripod or monopod.

ZOOM LENSES

The great advantage of a zoom lens is that the one unit provides a range of focal lengths. This means less to carry around and allows for precise framing and composition of the image. There are disadvantages – zooms of equivalent speed (ie maximum aperture) to prime lenses are heavy and bulky. Also, while the performance of the very best zoom lenses such as the 70–180mm Apo Vario Elmarit can equal equivalent prime lenses in almost all respects, their cost is considerable. The less exotic, standard zooms have smaller maximum apertures.

All the current Leica zoom lenses have separate focusing and zoom controls. This allows for a more precise and robust mechanical construction for the complex optical designs. Combined with careful ergonomic design, it also ensures comfortable handling and accurate focusing. In addition, in most cases it has been possible to avoid the front lens elements rotating when focusing or zooming. This means that polarizing filters can be used without their having to be reset whenever distance or focal length are changed.

THE 28-70/3.5-4.5 VARIO-ELMAR-R

28–70MM F3.5/4.5 VARIO ELMAR

This is a revised version of the original 1990 28–70mm, based on a very successful Sigma design modified and improved to meet specifications. The mount has been completely redesigned and there are detail changes in the optical components. Unlike all the other Leica zooms, the aperture does not remain constant throughout the focal length range – there is a reduction of 2/3 stop between the 28mm and 70mm focal length settings. The R cameras' metering system

WHITE NANCY, CHESHIRE, ENGLAND
Comparison pictures taken with the 28–70mm Vario at 28mm and 70mm. White Nancy is the obelisk on the hilltop!
Leica R8, 28–70/3.5–4.5 Vario Elmar, 1/250 sec at f8, Ektachrome 100 SW

takes care of the adjustment required. Performance wide open is good and by f8 it is very good. The lens is relatively free from reflections when shooting against the light, but there is a touch of barrel distortion at 28mm and pincushion at 70mm. For a zoom of this range, vignetting is quite well controlled and can be reduced to reasonable proportions by slight stopping down, even at 28mm. A good lens, very keenly priced.

HILL FARM, CHESHIRE, ENGLAND
The 70–180mm f2.8 Vario Elmarit brings a wide aperture and Apo quality to the range of Leica zoom lenses. The pictures are taken at 70mm and 180mm.
Leica R8, 70–180/2.8 Apo Vario Elmarit, 1/500 sec at f5.6, Ektachrome 100 SW

35–70MM F4 VARIO ELMAR

A quite remarkable new zoom from the Solms design team. The use of an aspheric element has facilitated the achievement of excellent optical quality at all apertures and throughout the zoom range. This lens also features reasonably close focusing, enabling an image ratio of 1:29 to be achieved while maintaining very good image quality. Good quality is also

maintained when it is used in conjunction with the 2x Apo Extender. This is a most useful and versatile lens, ideal when there is a need to travel light.

80–200MM F4 VARIO ELMAR

A Leica-designed lens built to Leica specification by Kyocera of Japan. This is another extremely fine performer, providing near prime lens quality. The closest focusing distance is a very useful 1.1m (3½ft) and this provides an image ratio of 1:3.9 at the 200mm setting. There is virtually no distortion at either end of the zoom range. Vignetting is well controlled and the lens delivers very good image quality at its maximum aperture of f4. It can be used with the 2x Apo Extender, but best performance with this combination requires that the lens be stopped down 1 or 2 stops. A very versatile lens with good handling.

70–180MM F2.8 APO VARIO ELMARIT

An absolutely stunning performer, designed and built by Leica at Solms. Within the normal focusing range the results are in no way inferior to equivalent prime Apo lenses. Bulky and heavy but with good ergonomics, the lens works extremely well

FROST AND STEAM

Cold mornings are a wonderful opportunity to photograph steam locomotives. This was something of a grab shot and I was glad to have a zoom lens on the camera that enabled me to achieve a suitable framing quickly. **Leica R8, 80–200/4 Vario Elmar 1/500 sec at f5.6, Kodachrome 200 Professional**

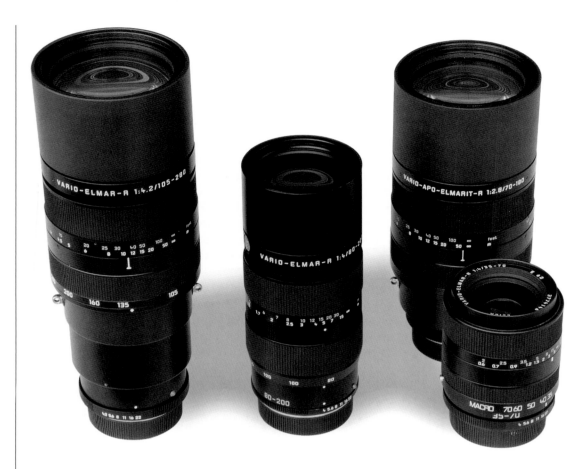

with the 2x Apo Extender even at full aperture, but in this combination needs to be refocused when the focal length is changed. The lens has a built-in tripod support which can be rotated for landscape or portrait format.

105–280MM F4.2 VARIO ELMAR

Introduced to meet continued requests from many professionals, this is Leica's first 'long' zoom lens. A derivation of the 70–180mm Apo zoom, it uses many of that lens's optical and mechanical components and also 'in-house' design and manufacture. It is of similar bulk and weight, and has equally good ergonomics. Although not quite up to the very high standard required to be designated Apo by Leica, the performance is comparable to conventional prime lenses. This lens also has a built-in tripod support point. It was the first Leica lens to incorporate a ROM chip for electronic information exchange with the Leica R8. Can be used with both the 1.4x and 2x Apo Extenders.

LEICA ZOOM LENSES

LEFT TO RIGHT: 105–280/4.2, 80–200/4, 70–180/2.8, 35–70/4.

Leica R8, 100/2.8 Apo Macro Elmarit, 1/4 sec at f16, Kodak T 400 CN

EXTENDERS

The Leica extenders are a convenient way of increasing the focal length of lenses, albeit with a significant loss of speed: 2 stops in the case of the 2x and 1 stop for the 1.4x. The optical quality of the combination depends on the quality of the prime lens and the efficiency of the 'match'. It should be noted that when fitted with an extender some lenses will focus beyond infinity. Care should be taken to focus accurately. When using a lens fitted with the ROM contacts, it is important that the extender is fitted first to the camera body. This ensures that the diaphragm lever is positioned where it cannot damage the contacts. A revised version of the 2x extender with its own ROM contacts is in preparation to overcome this requirement.

1.4X APO EXTENDER-R

This was originally designed specifically for use with the 280mm f2.8 Apo lens and carefully matched to maintain the Apo corrections. In this respect it succeeds superbly and the combination, which produces a 400mm f4, is as stunning as the 280mm itself. Be warned that the 1.4x cannot be used with

AMERICAN AIRLINES BOEING 767
The 1.4x Apo Extender was specifically designed to match the original 280mm f2.8 Apo Telyt. The combination produces outstanding results.
Leica R8, 280/2.8 Apo Telyt + 1.4x Apo Extender, 1/1000 sec at f4 (equal to f5.6), Ektachrome 100 SW

EXECUTIVE JET
In combination with the 180mm f3.4 Apo Telyt, the 2x Apo Extender-R has produced a superb result.
Leica R8, 180/3.4 Apo Telyt + 2x Apo Extender, 1/1000 sec at f4 (equal to f8), Kodachrome 200 Professional

most other lenses, because its front elements protrude into the rear of the prime lens and in most cases would damage the latter's rear elements. The 1.4x extender cannot be used on SL2 and earlier models. It can be used in all operational modes on the R cameras.

2X APO EXTENDER-R
The original extender has been redesigned to maintain Apo performances when matched with Apo lenses, and can be combined with any current R lens of 50mm or longer focal length other than the 50mm f1.4 Summilux and the 80mm f1.4 Summilux. It can be used without restriction in aperture priority and manual modes but not in programme or shutter speed priority. It cannot be used with SL2 and earlier Leicaflex cameras. A special version of the earlier 2x extender (code 11237) was available for these older cameras.

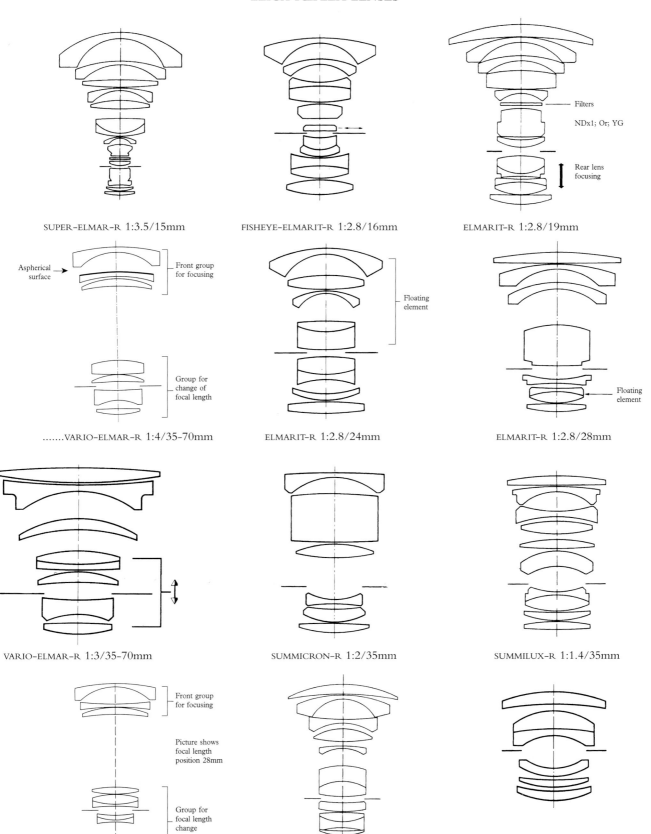

SUPER–ELMAR–R 1:3.5/15mm

FISHEYE–ELMARIT–R 1:2.8/16mm

ELMARIT–R 1:2.8/19mm

Filters

NDx1; Or; YG

Rear lens focusing

Aspherical surface

Front group for focusing

Group for change of focal length

Floating element

Floating element

.......VARIO–ELMAR–R 1:4/35-70mm

ELMARIT–R 1:2.8/24mm

ELMARIT–R 1:2.8/28mm

VARIO–ELMAR–R 1:3/35-70mm

SUMMICRON–R 1:2/35mm

SUMMILUX–R 1:1.4/35mm

Front group for focusing

Picture shows focal length position 28mm

Group for focal length change

VARIO–ELMAR–R 3.5-4.5/28-70mm

PC–SUPER–ANGULON–R 1:2.8/28mm

MACRO–ELMARIT–R 1:2.8/60mm

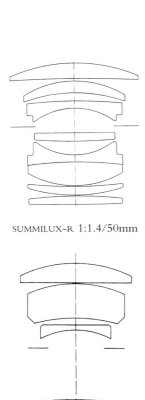

SUMMILUX-R 1:1.4/50mm

SUMMICRON-R 1:2/50mm

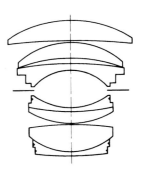

SUMMILUX-R 1:1.4/80mm

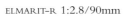

ELMARIT-R 1:2.8/90mm

SUMMICRON-R 1:2/90mm

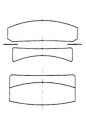

MACRO-ELMAR 1:4/100mm

APO-MACRO-ELMARIT-R 1:2.8/100mm

ELMARIT-R 1:2.8/135mm

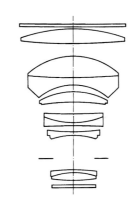

APO-SUMMICRON-R 1:2/180mm

APO-TELYT-R 1:3.4/180mm

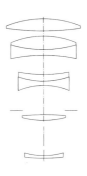

APO-ELMARIT-R 1:2.8/180mm

APO-TELYT-R 1:4/280mm

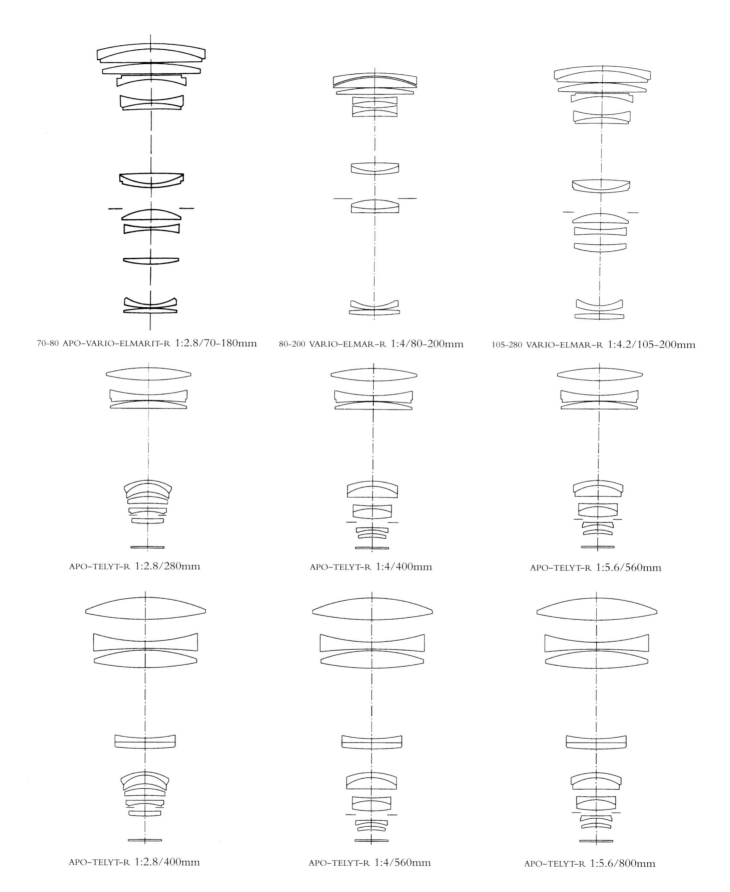

70-80 APO–VARIO–ELMARIT–R 1:2.8/70–180mm 80-200 VARIO–ELMAR–R 1:4/80–200mm 105-280 VARIO–ELMAR–R 1:4.2/105–200mm

APO–TELYT–R 1:2.8/280mm APO–TELYT–R 1:4/400mm APO–TELYT–R 1:5.6/560mm

APO–TELYT–R 1:2.8/400mm APO–TELYT–R 1:4/560mm APO–TELYT–R 1:5.6/800mm

Lens	Focal length (mm) maximum aperture	Angle of view (degrees)	Elements/groups	Smallest aperture	Focusing range	Smallest object area (mm)	Filter size	Length (mm)	Diameter (mm)	Weight (g)	Code
CURRENT LEICA R LENSES											
SUPER ELMAR-R	15 f3.5	110	13/12	f22	inf–0.16m	70x105	built-in	92.5	83.5	910	11213
FISHEYE ELMARIT-R	16 f2.8	180	11/8	f16	inf–0.3m	401x601	built-in	60	71	460	11222
ELMARIT-R	19 f2.8	96	12/10	f22	inf–0.3m	264x396	built-in	60	71	560	11258
ELMARIT-R	24 f2.8	84	9/7	f22	inf–0.3m	250x375	series 8	48.5	67	400	11257
PC SUPER ANGULON-R	28 f2.8	73/93	10/9	f22	inf–0.28m	146x219	67 EW	84	75	600	11812
ELMARIT-R	28 f2.8	76	8/7	f22	inf–0.3m	188x282	E55	40	63	310	11247
SUMMILUX-R	35 f1.4	64	10/9	f16	inf–0.5m	266x399	E67	76	75	690	11144
SUMMICRON-R	35 f2	64	6/6	f16	inf–0.3m	140x210	E55	54	66	430	11115
SUMMILUX-R	50 f1.4	45	8/7	f16	inf–0.5m	178x266	E60	51	70	490	11344
SUMMICRON-R	50 f2	45	6/4	f16	inf–0.5m	180x270	E55	41	66	290	11216
MACRO ELMARIT-R	60 f2.8	39	6/5	f22	inf–0.45m (with 1:1)	48x72 (24x36)	E55	62.3 (92.3)	67.5	400 (530)	11253
SUMMILUX-R	80 f1.4	30	7/5	f16	inf–0.8m	192x288	E67	69	75	700	11881
SUMMICRON-R	90 f2	27	5/4	f16	inf–0.7m	140x210	E55	61	69	520	11254
ELMARIT-R	90 f2.8	27	4/4	f22	inf–0.7m	140x210	E55	57	67	450	11154
APO MACRO ELMARIT-R	100 f2.8	25	8/6	f22	inf–0.45m (with Elpro)	48x72 (22x33)	E60	104.5 (140)	73	760 (950)	11210
MACRO ELMAR	100 f4	25	4/3	f22	bellows lens	22x33	E55	48.5	66	290	11270
ELMARIT-R	135 f2.8	18	5/4	f22	inf–1.5m	220x330	E55	93	67	730	11211
APO SUMMICRON-R	180 f2	14	9/6	f16	inf–1.5m	160x240	series 6★	176	116	2500	11271
APO ELMARIT-R	180 f2.8	14	7/5	f22	inf–1.5m	160x240	E67	132	76	972	11273
APO TELYT-R	280 f4	8.8	7/6	f22	inf–1.7m	120x180	E77/series 5.5★	208	90	1875	11261
APO TELYT-R	280 f2.8	8.8	8/7	f22	inf–2m	140x210	series 6★	276	125	3700	11846
APO TELYT-R	400 f2.8	6.2	10/8	f22	inf–3.7m	206x310	series 6★	344	157	5900	11847
APO TELYT-R	400 f4	6.2	9/7	f22	inf–2.15m	109x164	series 6★	314	125	3800	11857
APO TELYT-R	560 f4	4.5	11/8	f22	inf–3.9m	154x232	series 6★	382	157	6000	11848
APO TELYT-R	560 f5.6	4.5	9/7	f22	inf–2.15m	75x113	series 6★	374	125	3950	11858
APO TELYT-R	800 f5.6	3.1	11/8	f22	inf–3.9m	106x160	series 6★	442	157	6200	11849
VARIO ELMAR-R	28–70 f3.5/4.5	76–34	11/8	f22	inf–0.5m	340x510 150x225	E60	76	70	450	11364
VARIO ELMAR-R	35–70 f3.5	64–34	8/7	f22	inf–1.0m	632x947 338x507	E67	66.5	76.5	450	11248
VARIO ELMAR-R	35–70 f4	64–34	8/7	f22	inf–0.6m inf–0.26m (macro)	350x525 192x288 67x101	E60	84	70	400	11277
APO VARIO ELMAR-R	70–180 f2.8	34–14	13/10	f22	inf–1.7m	435x653 175x263	E77	189.5	89	1870	11267
VARIO ELMAR-R	80–200 f4	29–12.5	12/9	f22	inf–1.1m	222x333 94x140	E60	185	71	1020	11280
VARIO ELMAR-R	105–280 f4.2	23–8.8	13/10	f22	inf–1.7m	281x421 112x168	E77	238	89	1950	11268
APO EXTENDER-R 1.4x			5/4					36	62	220	11249
APO EXTENDER-R 2x			7/5					35.4	62	245	11262

★ In filter slot

66

EARLIER RANGEFINDER LENSES

EARLIER LEICA M LENSES

Examples of some earlier M lenses produced between 1960 and 1996.

FRONT ROW, LEFT TO RIGHT: 35/2 (1994), 50/2 dual range (1958), 21/3.4 (1970), 35/2.8 (1966), 35/2 M3 type (1967).

SECOND ROW: 50/2 (1979), 90/2.8 (1989), 21/2.8 (1991), 50/1 (1980).

BACK ROW: 90/4 collapsible (1961), 90/2.8 (1968), 135/4 (1978), 90/2 (1978).

Leica R8, 100/2.8 Apo Macro Elmarit, 1/4 sec at f16, Kodak T 400 CN

M LENSES

The table on page 78 lists all the discontinued lenses made for the M series of cameras since the introduction in 1954 of the M3. It is true to say that any one of these lenses in good condition will give a first-class account of itself. In fact, some would give even the current designs a close run. Lenses that I would mention specifically are the 21mm f3.4 Super Angulon, any of the 35mm Summicrons, the 50mm f2.8 Elmar, the rigid 50mm Summicron (particularly the 1969/79 model), the 90mm Summicron and the later model 90mm Tele-Elmarit. The

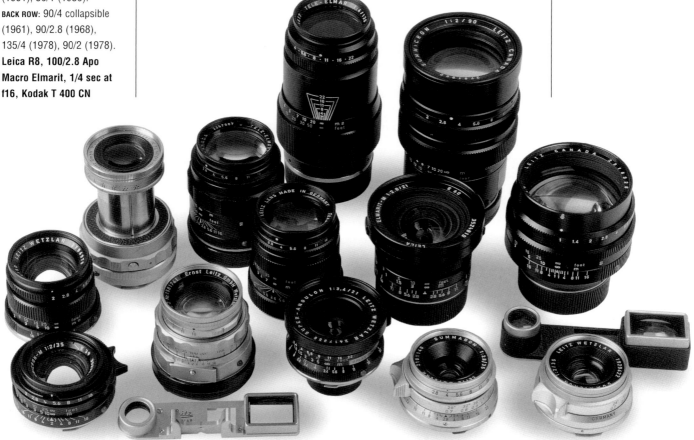

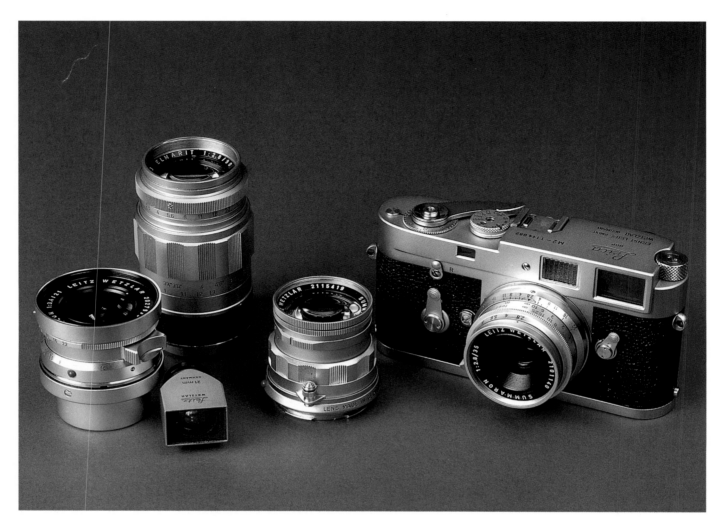

The 1966 camera is seen
with a set of contemporary
lenses: the 21mm f3.4
Super Angulon (and its
viewfinder), the 90mm f2.8
Elmarit, the 50mm f2 rigid
Summicron and, on the
camera, the 35mm f2.8
Summaron. Although now
over 30 years old, in good
condition these lenses can
still produce first-class
results.
**Leica RE, 100/2.8 Apo
Macro Elmarit, 1/2 sec at
f16, Kodachrome 200
Professional**

135mm f4 Elmar is bulkier but almost as good in performance
as it successor, the remarkable 135mm Tele-Elmar.

Two of the lenses listed are special limited edition designs.
These are the 35mm f1.4 Summilux Aspherical, the immediate
predecessor of the current 35mm f1.4 Summilux ASPH, and
the 50mm f2.8 Elmar, specially produced for the M6-J. The
original aspherical design incorporated two aspheric surfaces,
compared with the single one of the latest design. Two thousand
were planned for production but it is believed that fewer than
this number were eventually manufactured, due to the very
complex processes involved.

The special Elmar for the M6-J was re-computed optically
and redesigned mechanically compared with the earlier 50mm
f2.8 design. The newer lens is 20g lighter, focuses to 0.7m
(28in) instead of 1m (40in) and has a non-rotating focusing
mount. To match the M6-J requirement, 1,640 were produced.
Subsequently this lens, without the traditional infinity lock and
incorporating other cosmetic changes, was put into regular
production. It is currently available in both silver chrome and
black finish.

**ROTHENBURG OB DER
TAUBER, GERMANY**
The 21mm f2.8 Elmarit is an
excellent lens only bettered
by its remarkable ASPH
successor.
**Leica M6, 21/2.8 Elmarit,
1/60 sec at f4/5.6,
Kodachrome 25
Professional**

PETRIFIED FOREST, ARIZONA

The 1978 Canadian-manufactured 50mm Summicron used here is optically identical with the current version, which has a built-in lens hood and is made in Germany.

Leica M6, 50/2 Summicron, 1/250 sec at f4/5.6, Kodachrome 25 Professional

Both these lenses are superb performers capable of producing outstanding image quality. It should be noted also that the 50mm f1 Noctilux code 11821, 50mm Summilux code 11114, 50mm f2 Summicrons codes 11819 and 11825 included in the listing are all optically identical with the current lenses, with similar performance characteristics.

Leica have improved lens coatings over the years, so with a lens that has had a long production run, look for one with as high a serial number as possible. Approximate datings for serial numbers are:

number	date
500,000	1939
1,000,000	1952
1,500,000	1957
2,000,000	1964
2,500,000	1971
3,000,000	1979
3,500,000	1990
3,650,000	1995
3,800,000	1998

Early 50mm and 90mm Elmars tend to have a somewhat cool rendering and benefit from a skylight rather than a UVa filter.

RAWHIDE, PHOENIX

Any of the 35mm Summicrons can be recommended. The 1976 six-element (third version) used for this picture is highly regarded.

Leica M6, 35/2 Summicron, 1/125 sec at f5.6, Kodachrome 25 Professional

71

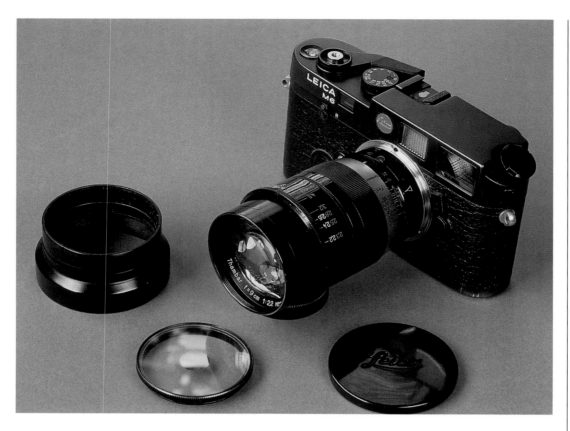

LEICA M6 WITH 90mm THAMBAR

This picture demonstrates the remarkable compatibility that has been maintained with the Leica rangefinder system. The 1935 Thambar portrait lens, equipped with a screw-mount to bayonet adapter, fits and couples accurately with the 1996 M6.

Leica R8, 100/2.8 Apo Macro Elmarit, 1/2 sec at f16, Ektachrome 100SW

When shooting in open shade or dull light, an 81B is worth trying. All the lenses listed can be fitted to any Leica other than the M5 or CL. Some lenses with projecting rear elements will not meter on the M6. These same lenses must not be used on the Leica M5 or CL as they will foul the meter arm. Collapsible lenses must not be collapsed on these two cameras either (for the same reason) and it is safest therefore not to use them (see the notes to the table on page 77.)

SCREW-MOUNT LENSES

With one or two exceptions concerning the Leica M5 and the Leica CL, any interchangeable screw-mount lens can, with the appropriate adapter, be fitted to any Leica M camera and will couple accurately with the rangefinder. However, the 21mm f4 will not meter correctly with the M6. Due to its projecting rear elements, this lens should not be fitted to the Leica M5 or the CL, and there are dangers in fitting any of the collapsible lenses to these two cameras – see above.

The very late screw-mount lenses were, in fact, identical to the equivalent M lenses apart from the mount, and similar recommendations apply. However, the last screw-mount lenses were made in 1964, so finding even a late one in top condition is likely to be more difficult and in any case you will be competing with the collectors. Apart from age deterioration,

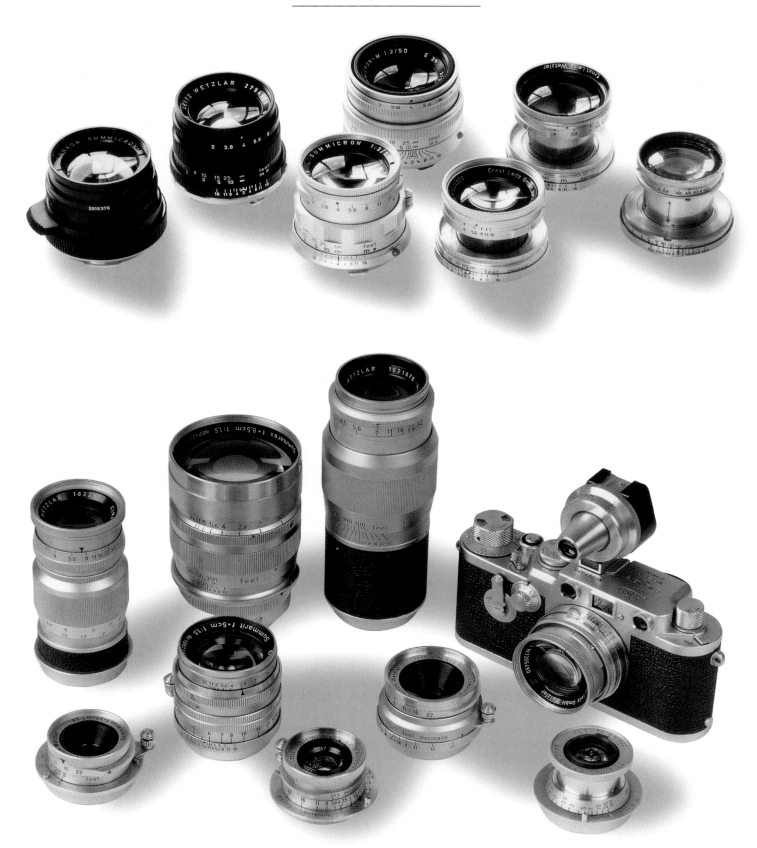

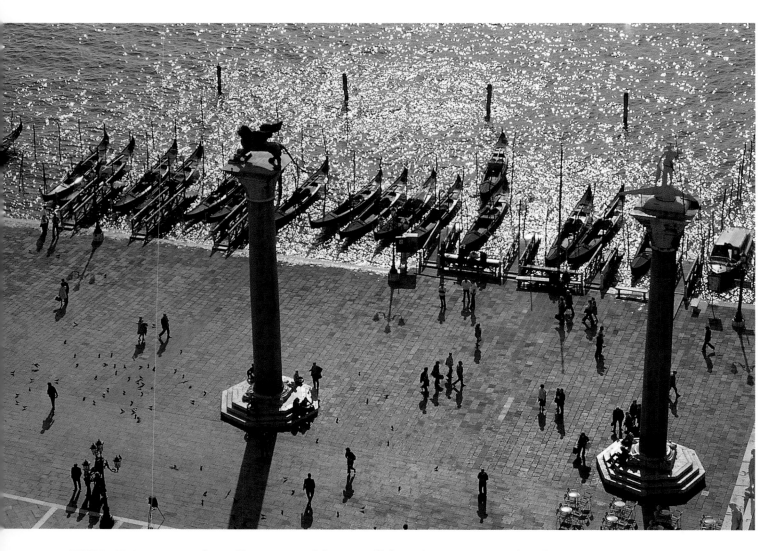

VENICE, ITALY

A shot taken with the early 1960s vintage 90mm Elmarit shown on page 68 with the M2 outfit. The lens is a screw-mount version bought secondhand. For an older lens, it has performed well in difficult *contre jour* lighting.

Leica M4, 90/2.8 Elmarit, 1/250 sec at f5.6/8, Kodachrome 25

earlier uncoated lenses will have less contrast and will be more susceptible to flare. These and some earlier coated lenses may have a somewhat variable colour rendering, as it was not until the 1960s that Leica introduced their patented 'absorban' cement layer that greatly facilitated efforts to achieve consistent colour transmission in the full range of lenses. Sophisticated coating techniques, including multi-coating, are now used to ensure a standardized colour rendition.

Two lenses that should be mentioned specifically as they never had an M bayonet equivalent are the 90mm Thambar, an early lens specially designed to give lovely soft-focus effects for portraiture, and the 85mm f1.5 Summarex, a remarkable achievement in its day and still a pretty good performer even by current standards.

The table on page 77 lists all the screw-mount lenses from 1930 onwards. Rangefinder coupling for all lenses was introduced from 1932 along with the Leica II (Model D in the USA), so you may just come across an earlier uncoupled lens. If you do, it could be extremely valuable to a collector.

VISOFLEX LENSES

Before the introduction of the Leicaflex reflex system, and for a few years afterwards, Leica produced a series of reflex housings that converted the rangefinder cameras into a single-lens reflex. Compared with a Leicaflex or Leica R camera, it has to be admitted that they represent a relatively clumsy and inconvenient approach, but they do enable the rangefinder cameras to be used for close-up and long-lens photography. Some very good and interesting lenses were provided for these reflex housings. A few of the later ones – the 400mm f5.6 and f6.8 Telyts and the 560mm f5.6 and f6.8 Telyts – were supplied in both Leica M and Leicaflex mount. As table 8 indicates, the various Visoflex lenses can be adapted readily to the Leicaflex and Leica R system, and certainly I have regularly used favourites such as the 65mm f3.5 Elmars, the 125mm f2.5 Hektor and the 400mm f6.8 Telyt on the reflex system as well as Visoflex.

Both versions of the 65mm f3.5 Elmar are excellent macro lenses, whether used in the universal focusing mount or on the Bellows 2 or Bellows R and BR2. With the R bellows units there is a particularly useful range of focus from infinity to 1.5x magnification and it is here that the TTL (through the lens) metering becomes invaluable. With modern high-quality films of ISO 100 and faster, the 400mm and 560mm f6.8 Telyts are perfectly viable for sports and wildlife photography in good light. The 400mm in particular is light and comfortable, so it

VISOFLEX LENSES

These four lenses are still in regular use by the author. The picture shows a 200mm f4, the two versions of the 65mm Elmar and the 125mm f2.5 Hektor. **Leica R8, 100/2.8 Apo Macro Elmarit, 1/2 sec at f16, Ektachrome 100 SW**

HARD ROCK CAFÉ, LAS VEGAS, USA
Another shot taken with the earlier 21mm Elmarit. Excellent quality even at full aperture.
Leica M6, 21/2.8 Elmarit, 1/30 sec at f2.8, Kodachrome 200 Professional

can be hand held and carried around for long periods without discomfort. With both this and the 560mm, performance is good at f6.8, and very good when stopped down to f8 and below. With the simple two-element optical construction there is slight curvature of field, but this is not significant for the kind of subject for which these lenses will be used.

The 200mm f4 is also a very good lens, although the direct focusing limit of 3m (10ft), without extension tubes, can be restrictive. For the portraitist, the 125mm f2.5 Hektor is highly prized as well as being sought after by collectors.

SCREW–MOUNT RANGEFINDER LENSES										
Lens	Note	Focal length (mm) maximum aperture	Angle of view (degrees)	Elements/groups	Smallest aperture	Focusing range	Filter size	Finish	Available from–to	Code
SUPER ANGULON		21 f4	92	9/4	f22	inf–0.4m	E39	chrome	1958–1962	SUOON
HEKTOR	(a)	28 f2.8	76	5/3	f25	inf–1m	A36	chrome	1935–1953	HOOPY
SUMMARON		28 f5.6	76	6/4	f22	inf–1m	A36	chrome	1955–1963	SNOOX
ELMAR	(a)	35 f3.5	64	4/3	f18	inf–1m	A36	chrome	1931–1939	EKURZ
SUMMARON		35 f3.5	64	6/4	f22	inf–1m	A36	chrome	1950–1956	SOONC
SUMMARON		35 f3.5	64	6/4	f22	inf–1m	E39	chrome	1956–1960	SOONC
SUMMARON		35 f2.8	64	6/4	f22	inf–1m	E39	chrome	1958–1963	SUMOO
SUMMICRON		35 f2	64	8/6	f16	inf–1m	E39	chrome	1958–1963	SAWOO
ELMAX★		50 f3.5	45	5/3	f18	inf–1m	A36	nickel	1924–1925	-
ELMAR★	(a)	50 f3.5	45	4/3	f22	inf–1m	A36	chrome	1926–1962	ELMAR
ELMAR★		50 f2.8	45	4/3	f22	inf–1m	E39	chrome	1957–1962	ELMOO
HEKTOR★	(a)	50 f2.5	45	6/3	f18	inf–1m	A36	chrome	1930–1939	HEKTOR
SUMMAR★	(a)	50 f2	45	6/4	f12.5	inf–1m	A36	chrome	1933–1940	SUMAR
SUMMITAR★		50 f2	45	7/4	f16	inf–1m	E36	chrome	1939–1953	SOORE
SUMMICRON★		50 f2	45	7/6	f16	inf–1m	E39	chrome	1953–1960	SOOIC
SUMMICRON		50 f2	45	7/6	f16	inf–1m	E39	chrome	1960–1962	SOSTA
XENON		50 f1.5	45	7/5	f9	inf–1m	special	chrome	1936–1949	XEMOO
SUMMARIT		50 f1.5	45	7/5	f16	inf–1m	E41	chrome	1949–1960	SOOIA
SUMMILUX		50 f1.4	45	7/5	f16	inf–1m	E43	chrome	1960–1963	SOWGE
HEKTOR		73 f1.9	34	6/3	f25	inf–1.5m	special	chrome	1932–1942	HEGRA
SUMMAREX	(b)	85 f1.5	28	7/5	16	inf–1.5m	E58	chrome	1943–1960	SOOCX
ELMAR	(b)	90 f4	27	4/3	f32	inf–1m	A36	chrome	1931–1958	ELANG
ELMAR		90 f4	27	4/3	f32	inf–1m	E39	chrome	1958–1963	ELANG
ELMAR		90 f4	27	3/3	f32	inf–1m	E39	chrome	1963–1964	11730
ELMARIT		90 f2.8	27	5/3	f22	inf–1m	E39	chrome	1959–1963	ELRIT
THAMBAR		90 f2.2	27	4/3	f25	inf–1m	E48	black	1935–1941	TOODY
SUMMICRON		90 f2	27	6/5	f22	inf–1m	E48	chrome	1957–1958	SOOZI
SUMMICRON		90 f2	27	6/5	f22	inf–1m	E48	chrome	1959–1962	SEOOF
ELMAR		105 f6.3	23	4/3	f36	inf–3m	A36	black	1932–1937	ELZEN
ELMAR		135 f4.5	18	4/3	f36	inf–1.5m	A36	black	1931–1933	EFERN
HEKTOR	(b)	135 f4.5	18	4/3	f32	inf–1.5m	A36	chrome	1933–1956	HEFAR
HEKTOR		135 f4.5	18	4/3	f32	inf–1.5m	E39	chrome	1956–1960	HEFAR
ELMAR		135 f4.0	18	4/4	f22	inf–1.5m	E39	chrome	1960–1964	11750

★ Collapsible mount: See main text (a) Nickel finish on some early lenses (b) Black finish on early lenses

Lens	Note	Focal length (mm) maximum aperture	Angle of view degrees	Elements/groups	Smallest aperture	Focusing range	Filter size	Weight (g)	Finish	Available from-to	Code
EARLIER LEICA M LENSES											
HOLOGON		15 f8	110	3/3	f8	inf–0.2m	special	120	black	1973–1976	11135
SUPER ANGULON		21 f4	92	9/4	f22	inf–0.4m	E39	250	chrome	1958–1963	11102
SUPER ANGULON	(f)	21 f3.4	92	8/4	f22	inf–0.4m	E48/S7	300	black	1963–1980	11103
ELMARIT-M		21 f2.8	92	8/6	f16	inf–0.7m	E60	290	black	1980–1997	11134
ELMARIT		28 f2.8	76	9/6	f22	inf–0.7m	E48/S7	225	black	1965–1969	11801
ELMARIT	(a)	28 f2.8	76	8/6	f22	inf–0.7m	E48/S7	225	black	1969–1980	11801
ELMARIT		28 f2.8	76	8/6	f22	inf–0.7m	E49	240	black	1980–1993	11804
SUMMARON (M3 type)		35 f3.5	64	6/4	f22	inf–1m	E39	220	chrome	1956–1958	11107
SUMMARON		35 f3.5	64	6/4	f22	inf–1m	E39	135	chrome	1958–1959	11305
SUMMARON (M3 type)		35 f2.8	64	6/4	f22	inf–0.65m	E39	220	chrome	1958–1973	11106
SUMMARON		35 f2.8	64	6/4	f22	inf–0.7m	E39	135	chrome	1958–1973	11306
SUMMICRON (M3 type)		35 f2	64	8/6	f16	inf–0.65m	E39	250	black	1958–1973	11104
SUMMICRON (M3 type)		35 f2	64	8/6	f16	inf–0.65m	E39	250	chrome	1958–1973	11108
SUMMICRON		35 f2	64	8/6	f16	inf–0.7m	E39	150	black	1958–1969	11307
SUMMICRON		35 f2	64	8/6	f16	inf–0.7m	E39	150	chrome	1958–1969	11308
SUMMICRON		35 f2	64	6/4	f16	inf–0.7m	S7	170	chrome	1969–1973	11309
SUMMICRON	(b)	35 f2	64	6/4	f16	inf–0.7m	E39/S7	170	black	1973–1980	11309
SUMMICRON-M		35 f2	64	7/5	f16	inf–0.7m	E39	160	black	1980–1997	11310
SUMMICRON-M		35 f2	64	7/5	f16	inf–0.7m	E39	250	chrome	1992–1997	11311
SUMMILUX		35 f1.4	64	7/5	f16	inf–1m	S7	195	chrome	1961–1994	11870
SUMMILUX-M titanium		35 f1.4	64	7/5	f16	inf–1m	S7	195	titanium	1992–1994	11860
SUMMILUX (M3 type)		35 f1.4	64	7/5	f16	inf–0.65m	S7	325	black	1960–1974	11871
SUMMILUX-M ASPHERIC		35 f1.4	64	9/5	f16	inf–0.7m	E46	300	black	1990–1994	11873
ELMAR	(c)	50 f3.5	45	4/3	f22	inf–1m	E39	210	chrome	1954–1962	11110
ELMAR	(c)	50 f2.8	45	4/3	f22	inf–1m	E39	220	chrome	1958–1966	11112
ELMAR (M6J special)	(c)	50 f2.8	45	4/3	f16	inf–0.7m	E39	200	chrome	1994	12549
SUMMICRON	(c)	50 f2	45	7/6	f16	inf–1m	E39	220	chrome	1954–1957	11116
SUMMICRON		50 f2	45	7/6	f16	inf–1m	E39	285	chrome	1957–1969	11818
SUMMICRON		50 f2	45	7/6	f16	inf–1m	E39	285	black	1957–1969	11117
SUMMICRON (close–focus)		50 f2	45	7/6	f16	inf–0.48m	E39	400	chrome	1956–1968	11918
SUMMICRON		50 f2	45	6/5	f16	inf–0.7m	E39	260	black	1969–1979	11817
SUMMICRON-M		50 f2	45	6/4	f16	inf–0.7m	E39	225	black	1980–1994	11819
SUMMICRON-M		50 f2	45	6/4	f16	inf–0.7m	E39	295	chrome	1993–1994	11825
SUMMARIT		50 f1.5	45	7/5	f16	inf–1m	E41	320	chrome	1954–1960	11120
SUMMILUX	(d)	50 f1.4	45	7/5	f16	inf–1m	E43	325	black	1959–1995	11114
NOCTILUX		50 f1.2	45	7/6	f16	inf–1m	S7	515	black	1966–1975	11820
NOCTILUX		50 f1.0	45	7/6	f16	inf–1m	E60	630	black	1976–1994	11821
ELMAR		90 f4	27	4/3	f32	inf–1m	E39	240	chrome	1954–1963	11130
ELMAR	(c)	90 f4	27	4/3	f32	inf–1m	E39	300	chrome	1954–1968	11131
ELMAR		90 f4	27	3/3	f32	inf–1m	E39	220	chrome	1964–1968	11830

continued

Lens	Note	Focal length / max aperture	Angle of view	Elements/groups	Smallest aperture	Focusing range	Filter size	Weight	Finish	Available from–to	Code
ELMARIT	(e)	90 f2.8	27	5/3	f22	inf–1m	E39	330	chrome	1959–1974	11129
TELE-ELMARIT	(f)	90 f2.8	27	5/5	f16	inf–1m	E39	355	black	1964–1974	11800
TELE-ELMARIT		90 f2.8	27	4/4	f16	inf–1m	E39	225	black	1974–1990	11800
SUMMICRON	(g)	90 f2	27	6/5	f22	inf–1m	E48	660	black	1957–1979	11123
SUMMICRON-M		90 f2	27	5/4	f16	inf–1m	E55	475	black	1979–1998	11136
SUMMICRON-M silver		90 f2	27	5/4	f16	inf–1m	E55	690	chrome	1992–1998	11137
HEKTOR		135 f4.5	18	4/3	f32	inf–1.5m	E39	560	chrome	1954–1960	11135
ELMAR		135 f4.0	18	4/4	f22	inf–1.5m	E39	550	chrome	1960–1965	11850
TELE-ELMAR		135 f4.0	18	5/3	f22	inf–1.5m	E39	510	black	1965–1994	11851
TELE-ELMAR		135 f4.0	18	5/3	f22	inf–1.5m	E46	550	black	1994–1998	11861
ELMARIT	(h)	135 f2.8	18	5/4	f32	inf–1.5m	S7	730	black	1963–1998	11829

(a) New design from serial 2314921 (b) New design from serial 2461001 (c) Collapsible mount
(d) New optical design from serial 1844001, lenses prior to 1969 usually in chrome finish (e) Lenses after mid 1958 in black finish
(f) Chrome finish prior to 1967 (g) Lenses until 1964 usually in chrome finish (h) Optical design changed at serial 2656667 E55 filter from 2788927

VISOFLEX LENSES

Lens	Note	Focal length (mm) maximum aperture	Angle of view (degrees)	Elements/groups	Smallest aperture	Focusing range	Filter size	Finish	Available from–to	Code
ELMAR	(a)	65 f3.5	36	4/3	f22	inf–0.33m	E41	chrome	1960–1969	11062
ELMAR	(a)	65 f3.5	36	4/3	f22	inf–0.33m	S6	black	1969–1984	11162
HEKTOR	(b) (e)	125 f2.5	20	4/3	f22	inf–1.2m	E58	chrome	1954–1963	11032
TELE-ELMARIT	(d) (e)	180 f2.8	14	5/3	f22	inf–1.8m	S7	black	1965	11910
TELYT	(b) (e)	200 f4.5	12	5/4	f36	inf–3m	E48	black	1935–1958	OTPLO
TELYT	(b) (e)	200 f4	12	4/4	f22	inf–3m	E58	black	1959–1984	11063
TELYT	(b) (e)	280 f4.8	8.5	4/4	f22	inf–3.5m	E58	black	1961	11902
TELYT	(b) (e)	280 f4.8	8.5	4/4	f22	inf–3.5m	E58	black	1961–1970	11912
TELYT	(d) (e)	280 f4.8	8.5	4/4	f22	inf–3.5m	S8	black	1970–1984	11914
TELYT	(b)	400 f5	6	5/4	f36	inf–8m	E85	black	1936–1955	TLCOO
TELYT	(b)	400 f5	6	4/3	f32	inf–8m	E85	black	1956–1966	TLCOO
TELYT	(f) (c)	400 f5.6	6	2/1	f32	inf–3.6m	S7	black	1966–1971	11866
TELYT	(d) (c)	400 f6.8	6	2/1	f32	inf–3.6m	S7	black	1970–1984	11966
TELYT	(f) (c)	560 f5.6	4.3	2/1	f32	inf–6.6m	S7	black	1966–1971	11867
TELYT	(d) (c)	560 f6.8	4.3	2/1	f32	inf–6.4m	S7	black	1970–1984	11864

(a) For use with 16464 Universal focusing mount. Can also be used on focusing bellows (b) Adapter 16466 required with Visoflex II/III
(c) Filter fits in special filter slot (d) Not for use on Visoflex I or PLOOT (e) Lens head can be used on focusing bellows
GENERAL NOTES:
1) Many earlier 90mm and 135mm lenses have removable lens heads that will fit the various reflex housings and/or bellows units via special focusing mounts or adapters. Shorter focal lengths may also fit direct but only give close-up focus.
2) Lenses that either fit or have been adapted for use on Visoflex II or III can be fitted to Leicaflex and Leica R cameras via adapter 14167. Adapter 16863 allows 65/3.5 Elmars and 90/2.8 Elmarit or 135/4 Elmar lens-heads to fit Bellows R.

LEICA REFLEX HOUSINGS

PLOOT	Available	1935–1951	screw mount	VISOFLEX II	Available	1959–1963	screw and bayonet mount
VISOFLEX I	Available	1951–1959	screw and bayonet mount	VISOFLEX III	Available	1963–1983	bayonet mount

Chapter 6

EARLIER LEICA R LENSES

Since Leica's first single-lens reflex – the Leicaflex 1 – made its appearance in 1965, the versatility of the system has encouraged continuous expansion and development of the range of lenses on offer. Advances in camera design have also necessitated some changes in important details of the lens mounting. Despite this, the basic bayonet fitting has been retained throughout and, with a modification service available from the factory or national distribution organizations, over the years a quite remarkable degree of compatibility has been maintained.

LENS CAMMING

The first Leicaflex lenses for models I and II had a single cam to connect with their (non-TTL) meter. When the Leicaflex SL was introduced in 1968, a second cam was added to handle the requirements of TTL (through the lens) metering. With the 1974 SL2, the original cam was used to provide information in the viewfinder as to the stop set.

A major change came with the first of the R series cameras, the R3, in 1976. A much simpler R cam provided the necessary connection with the camera's metering system. To maintain compatibility with Leicaflex models, lenses were manufactured

LEICA R CAMMING VARIATIONS

The lens on the left is fitted with an 'R' cam (the small black stepped piece of metal at the top), and also, at the bottom, the R8 ROM electrical contact strip. The lens on the right is 'triple cammed' and can be identified by the two shiny metal cams with the black, stepped, 'R' cam showing inside the upper of the 'twin-cam' pair.
Leica R8, 100/2.8 Apo Macro Elmarit, 1/4 sec at f16, Kodak T 400 CN

LEICA 'R' LENS COMPATIBILITY

LEICA LENS CAMS for exposure control and finder information:

Single Cam	– for Leicaflex I/II only
Twin Cam	– for Leicaflex SL, SL2 and Leicaflex I/II
Triple Cam	– this is twin cam with additional R Cam – suitable for all Leica SLR's
R Cam only	– for R3 and later cameras – not suitable for Leicaflex I/II, SL or SL2 cameras
R8 Electrical contacts	– these are fitted in the same position as the first (single) cam. Lenses so equipped must not be used on Leicaflex I/II, SL or SL2 as damage will result.

Lenses up to 1968 were supplied single cam. Those from 1968 to 1976 were twin cam. From 1976 to 1988 they were generally (but not always) triple cam as some, including the 50/2 Summicron, were R cam only. From 1988 lenses were increasingly supplied with R cam only. In 1996 the R8 electronic contacts were introduced and lenses will steadily be made available with this option.

Earlier lenses may have been modified to a later specification. Check with the illustrations below. Note that the 15/3.5, 16/2.8, 24/2.8, 35/1.4 and 80-200 f4.5 will not fit Leicaflex I/II and SL, and bulky lenses are likely to obscure the meter on Leicaflex I/II.

LEICA REFLEX LENS CAMS

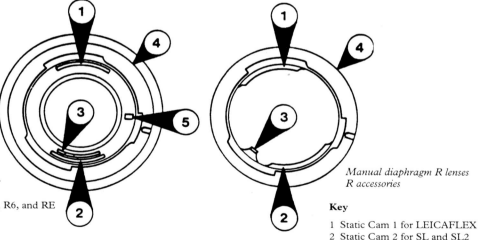

Auto diaphragm R lenses

Key

1 1st Cam for LEICAFLEX*†
2 2nd Cam for SL and SL2
3 3rd 'R' Cam for R3, R4, R5, R6, and RE
4 Red Index
5 Auto Diaphragm Coupling

Notes

Exposure measurements are made at full aperture. Cam 'instruct' meter what this is and the compensation required to suit the use of smaller apertures.
 Single and Twin Cam lenses discontinued.
*Also for operating viewfinder display of aperture on SL2.

† From 1996 this position may be occupied by electrical contacts for Leica R8.

Manual diaphragm R lenses
R accessories

Key

1 Static Cam 1 for LEICAFLEX
2 Static Cam 2 for SL and SL2
3 Static Cam 3 for R3, R4, R5, R6, and RE
4 Red Index

Notes

Static Cams zero the meter to allow accurate stop-down metering. With 'FLEX, Static Cam 1 brings meter to the f/11 equivalent.
 Static Cams 1 and 2 may appear to be a continuous surface on some items.
 Items with Static Cam(s) 1 or 2 or 1 and 2 discontinued.

with the earlier two cams also incorporated. The one exception was the 50mm Summicron, which from the start was available with either R cam only or 'triple' cammed. At that time, the earlier twin-cam lenses could be modified to incorporate the R cam at a heavily subsidized cost.

As the R series cameras evolved over a 20 year period, the demand for triple-cam lenses naturally reduced, and by 1996 most lenses were supplied with R cam only.

From late 1996, following the announcement of the R8, a ROM chip which provided extra facilities was incorporated into new lenses. The strip with the lens-to-camera contacts is located in the same position as the first Leicaflex cam, so lenses fitted with this contact strip cannot be used on Leicaflex I/II, SL and SL2 cameras. Note, however, that any earlier lens with an R cam can be used in the R8.

The details of the lens cam variations that have evolved over the years are summarized on page 81, together with illustrations to help you identify these variations. The table on page 12, which lists the Leica reflex cameras, indicates the cam requirements of each model, but there are some other essential points to remember:

1 'Triple-cam' lenses can be used on any camera from the SL2 onwards. The great majority will also fit the Leicaflex I/II and the Leicaflex SL.
2 Lenses with ROM contacts must not be used on Leicaflex SL2 and earlier Leicaflex cameras.
3 R cam lenses can be used on Leica R3 and all later R cameras. Single- and twin-cam lenses should not be used on R cameras.

Generally speaking, lenses produced from 1976 on will be triple-cam or R cam types. From 1997 they will be R cam with ROM.

EARLIER LENSES

Several current R lenses are optically identical to earlier designs. Changes have been made to the mounts to rationalize filter sizes and incorporate cam changes. Comments on the performance characteristics of the current lenses in Chapter 4 apply equally to such older designs, although it should be noted that with all

CACTUS

The 100mm f4 Elmar in a focusing mount was the predecessor of the Apo-Macro-Elmarit. This version was discontinued in 1996 but can still be considered a very good performer.

Leica R4, 100/4 Elmar, 1/125 sec f5.6/8, Kodachrome 25

lenses produced over a long period of time, improvements in coatings and maybe even minor changes to the glass types used will possibly have enhanced performance.

Earlier lenses that are the same optically as current models are:

Macro Elmarit	60mm f2.8	(11239)
Summicron	90mm f2	(11219)
Macro Elmar	100mm f4	(11230 and 11232)

Other lenses that have been discontinued, some fairly recently, and are recognized as particularly good performers are:

Super Angulon	21mm f4	(11813)
Elmarit	28mm f2.8	(11204 and 11207)
Elmarit	35mm f2.8	(11231)
Apo Telyt-R	180mm f3.4	
Apo Telyt-R	280mm f2.8	(11245 and 11263)
Telyt	400mm f6.8	(11980)

The Super Angulon 21mm f4 has been a long-time favourite of mine. It is only recently that I have started to use the latest 19mm f2.8 in preference. There is no doubt that in absolute terms the newer lens, as well as being faster and more compact, gives better sharpness – especially in the corners of the image – but the difference is that between very good and outstanding! A similar comment applies to both the 28mm and 35mm Elmarits. The older 28mm is more compact than its successor but lacks the built-in hood and convenient 55mm filter size. The 35mm

NEW YORK

A view from the roof of the RCA building at the Rockefeller Center. The zoom was ideal for precise framing.

Leica R4s, 70–210/4 Vario Elmar, 1/500 sec at f4/5.6, Kodachrome 64

Elmarit has no direct replacement, although there are now two zoom lenses that cover this focal length. Apart from being 1 stop slower, its performance is comparable to the current 35mm Summicron.

The new Apo Module system has rationalized the provision of longer focal lengths, and the 280mm f2.8 Apo Telyt and 400mm f6.8 Telyt were included among the lenses discontinued as part of this rationalization. I mention these two for quite different reasons. The 280mm Apo Telyt is a quite outstanding performer. With the 1.4x Apo Extender (which was specifically designed for this lens) you have an equally outstanding 400mm f4, and with the 2x Apo Extender you have a very good 560mm f5.6. The 400mm Telyt is a classic, wonderfully light and easy to handle, that is viable for many subjects in reasonable light and using the high quality available from today's faster films. With the simple two-element optical construction there is slight curvature of field, but with the kind of subject for which this lens is used this is rarely a problem. Performance is good at full aperture and very good from f8.

The 400mm Telyt was also available in Visoflex mount and this can be adapted easily to the reflex cameras. Some other Visoflex lenses are well worth considering for use on the R system, and I have referred to these on pages 75-6. The adapter for the Visoflex lenses to Leica R is the 14167. If you buy one of these secondhand, do make sure that it is a later one with the R cam (see page 81).

All the earlier zoom lenses were non-Leica designs. Leica selected the best from other manufacturers' ranges, and these were re-engineered to Leica specifications and the products

CLIMB OUT

Although slow by current standards, the 400mm and 560mm f6.8 Telyts are excellent lenses and very comfortable to handle. Improvements in faster speed films have made them fully viable for many action subjects.
Leica RE, 560/6.8 Telyt, 1/1000 sec at f8, Kodachrome 200 Professional

**IMMATURE GANNETS,
BASS ROCK, SCOTLAND**

When it was introduced in 1984, the 280mm f2.8 Apo Telyt set remarkable new standards for performance and handling. Except in the near range, you would be hard pressed to see any significant difference when compared with the latest Apo Module equivalent and many photographers still prefer the handling of this older lens.

Leica R4, 280/2.8 Apo Telyt, 1/500 sec at f4, Kodachrome 64 Professional

quality controlled to Leica standards. In particular, for a period Leica had an arrangement with Minolta to exchange technical know-how and develop a number of products jointly. As well as the now discontinued zoom lenses, each of which was a performance leader at the time of its introduction, the current 16mm f2.8 and 24mm f2.8 originated with Minolta.

Two catadioptric (mirror) lenses, the 500mm f8 and the 800mm f8, now discontinued, were also Minolta designs. The advantages of mirror lenses are that they are extremely compact and light for their focal length. The disadvantages are the relatively slow maximum aperture with the resulting dim viewfinder image that is difficult to focus; the lack of any aperture control, so that exposure can only be controlled by varying the shutter speeds or using neutral density filters; and the doughnut-shaped out-of-focus highlights that can be very irritating with some subjects. The 800mm MR-Telyt was only available to special order and, it should be noted, could not be equipped with the R cam. Convenient use is therefore restricted to the SL and the SL2 if you wish to rely on the camera's built-in metering system, although it is possible to meter using R cameras by applying a +2 stop correction to the indicated exposure. If you use a separate meter, remember that because of the optical construction the true light-passing stop is nearer f10 than the nominal f8.

Generally speaking, however, lenses without an R cam should not be used on R cameras (R3 and later) as damage may be caused to the camera/lens linkages.

EARLIER LEICA R LENSES

Lens	Focal length (mm) maximum aperture	Elements /groups	Minimum aperture	Focusing range	Filter size	Available from–to	Length (mm)	Weight (g)	Code	Comment
ELMARIT	19 f2.8	9/7	f16	inf–0.5m	E82	1975–1990	60	500	11225	
SUPER-ANGULON	21 f3.4	8/4	f22	inf–0.2m	S8.5	1964–1968	22	230	11803	Leicaflex I/II only, ex Schneider
SUPER-ANGULON	21 f4	10/8	f22	inf–0.2m	S8.5	1968–1994	43.5	410	11813	Ex Schneider
ELMARIT	28 f2.8	8/8	f22	inf–0.3m	E48	1970–1994	40	275	11204	also 11247 (R cam only)
ELMARIT	35 f2.8	7/6	f22	inf–0.3m	S6	1964–1974	40	400	11201	to serial 2517850
ELMARIT	35 f2.8	7/6	f22	inf–0.3m	E48/S7	1974–1979	40	305	11201	new optical design
ELMARIT	35 f2.8	7/6	f22	inf–0.3m	E55	1979–1996	41.5	305	11231	
SUMMICRON	35 f2	9/7	f16	inf–0.3m	E48/S7	1972–1976	61	525	11227	
PC CURTAGON	35 f4 PC	7/6	f22	inf–0.3m	S8	1969–1996	51	290	11202	Ex Schneider
SUMMILUX	50 f1.4	7/6	f16	inf–0.5m	S7	1969–1978	47	460	11875	
SUMMILUX	50 f1.4	7/6	f16	inf–0.5m	E55	1978–1998	50.6	400	11776	also 11777 (R cam only)
SUMMICRON	50 f2	6/5	f16	inf–0.5m	S6	1964–1976	38.5	340	11228	
MACRO ELMARIT	60 f2.8	6/5	f22	inf–0.27m	S7	1972–1980	67	450	11205	
ELMARIT	90 f2.8	5/4	f22	inf–0.7m	S7	1964–1983	72	515	11239	
SUMMICRON	90 f2	5/4	f16	inf–0.7m	S7	1969–1987	62.5	560	11219	E55 filter from serial 2770950
MACRO ELMAR	100 f4	4/3	f22	bellows lens	S7	1968–1992	62.5	365	11230	E55 filter from serial 2933351
MACRO ELMAR	100 f4	4/3	f22	inf–0.6m	E55	1980–1996	90	540	11232	version in focusing mount
ELMARIT	135 f2.8	5/4	f22	inf–1.5m	S7	1964–1968	91	730	11211	earlier optical design
ELMAR	180 f4	5/4	f22	inf–1.8m	E55	1976–1996	100	540	11922	
APO TELYT	180 f3.4	7/4	f22	inf–2.5m	E60	1975–1998	135	750	11242	S7.5 filter below 2947024
ELMARIT	180 f2.8	5/4	f16	inf–2.0m	E72/S8	1968–1979	134	1325	11919	
ELMARIT	180 f2.8	5/4	f22	inf–1.8m	E67	1979–1998	121	810	11923	
TELYT	250 f4	6/5	f22	inf–4.5m	E72/S8	1970–1979	154	1410	11920	
TELYT	250 f4	7/6	f22	inf–1.7m	E 67	1980–1994	195	1230	11925	
APO TELYT	280 f2.8	7/4	f22	inf–2.5m	E112	1984–1992	261	2750	11245	
APO TELYT	280 f2.8	7/4	f22	inf–2.5m	S5.5 ★	1992–1996	261	2800	11263	as 11245 with filter slot
TELYT	350 f4.8	7/5	f22	inf–3.0m	E77	1980–1994	286	1820	11915	
TELYT	400 f6.8	2/1	f32	inf–3.6m	S7 ★	1971–1990	384	1830	11960	later lenses take E72 filter
TELYT	400 f6.8	2/1	f32	inf–2.4m		1990–1996	406	2930	11926	ex Novoflex
TELYT	400 f5.6	2/1	f32	inf–3.6m	S7 ★	1968–1971	390	2350	14154	
APO TELYT	400 f2.8	11/9	f22	inf–2.5m	S5.5 ★	1992–1996	365	5500	11260	
MR-TELYT	500 f8	5/5	f8	inf–4.0m	E 77	1980–1996	121	750	11243	mirror lens ex Minolta
TELYT	560 f6.8	2/1	f32	inf–6.4m	S7 ★	1972–1996	530	2330	11865	
TELYT	560 f6.8	2/1	f32	inf–4.15m		1990–1996	534	3200	11927	ex Novoflex
TELYT	560 f5.6	2/1	f32	inf–6.6m	S7 ★	1968–1971	536	3455	14155	
MR-TELYT	800 f8	8/7	f8	inf–8.0m		1976–1978	166.5	1800		mirror lens ex Minolta ★★
TELYT-S	800 f6.3	3/1	f32	inf–12.5m	S7 ★	1973–1996	790	6860	11921	
VARIO ELMAR	28–70 f3.5/f4.5	11/8	f22	inf–0.5m	E 60	1990–1997	84	465	11265	ex Sigma
VARIO ELMAR	35–70 f3.5	8/7	f22	inf–1.0m	E 60	1983–1988	66.5	420	11244	ex Minolta
VARIO ELMAR	45–90 f4.5	15/12	f22	inf–1.0m	S7	1969–1982	122	774	11930	ex Angenieux
VARIO ELMAR	70–210 f4	12/9	f22	inf–1.1m	E60	1984–1996	157	720	11246	ex Minolta
VARIO ELMAR	75–200 f4.5	15/11	f22	inf–1.2m	E55	1978–1984	157	725	11226	ex Minolta
VARIO ELMAR	80–200 f4.5	14/10	f22	inf–1.8m	E55	1974–1978	157	710	11224	ex Minolta

★ In filter slot ★★ Leicaflex SL and SL2 only

Chapter 7

VIEWPOINT, PERSPECTIVE AND DEPTH OF FIELD

The ability to interchange lenses on the Leica is not just a question of 'getting more in' with a wide angle or picking out distant detail with a telephoto. Obviously this is important, but thoughtful choice of lens is one of the most important compositional tools available to the photographer.

VIEWPOINT

By changing the focal length of the lens on the camera it is possible, even without moving and changing viewpoint, to include carefully selected elements of the subject in the picture. The series of pictures of Bryce Canyon taken from precisely the

BENTLEY CONTINENTAL
Using a wide angle lens ensured that this lovely old car was dominant and the landscape secondary.
Leica M6, 35/2 Summicron, 1/125 sec at f5.6, Kodachrome 25 Professional

91

BRYCE CANYON, UTAH, USA

This series of pictures were all taken from the same position to show the angle of view encompassed by a range of focal lengths.
Leica R8, 1/500 sec at f5.6, Ektachrome 100 SW

19mm f2.8 Elmarit

35mm f2 Summicron

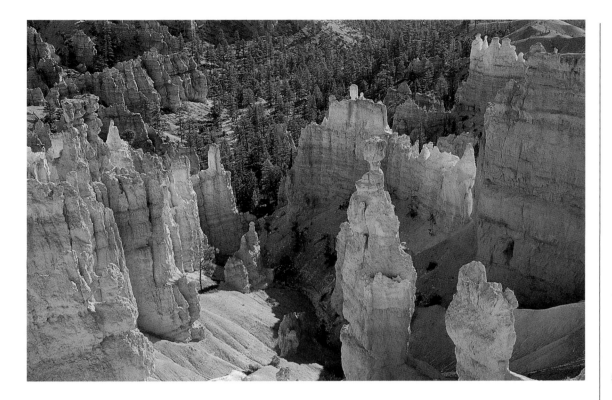

50mm f2 Summicron

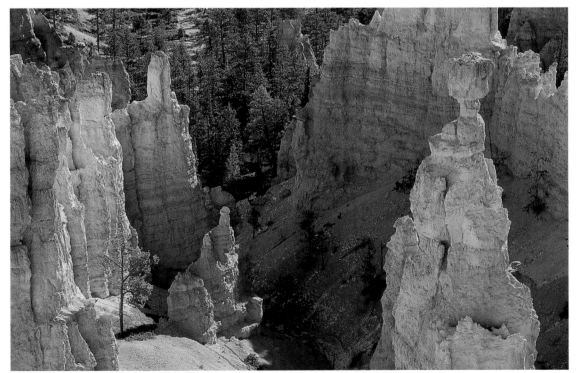

100mm f2.8 Apo Macro
Elmarit

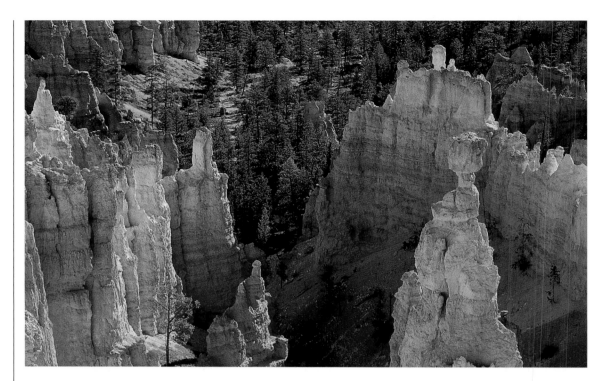

**80–200mm f4 Vario
Elmar at 80mm**

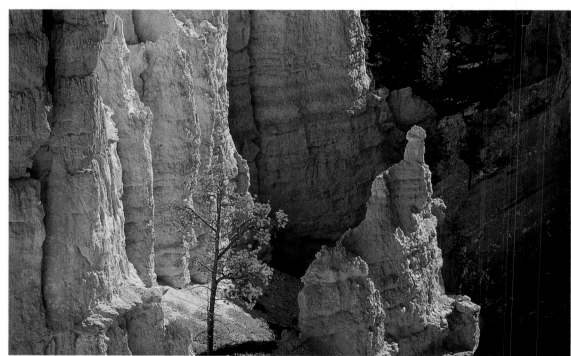

**80–200mm f4 Vario
Elmar at 200mm**

same position with the range of focal lengths from 19mm to 200mm demonstrates how dramatically an image can be varied simply by changing a lens. Bryce Canyon happens to be one of those rare subjects where an attractive image can be produced with almost any lens, but many others are so situated that photographers find themselves very restricted in the choice available. The picture of Hard Rock Café on page 84 is a good example: here it was absolutely necessary to get in close and then use an extreme wide angle lens in order to avoid the inclusion of power lines, street lights and telephone cables.

PERSPECTIVE

Often, in order to include the same elements of the main subject, there are alternative approaches: you can move in close with a wide angle or work from further away with a standard lens or a telephoto. Changing the position of the camera in relation to the main subject changes the perspective. This is because the relationship between the main subject and the background or foreground elements changes. Close in with a wide angle, and the foreground subject area is dominant; while much more of the background is included, it is on a much smaller scale – very much secondary to the subject. Taken from

THE WATCHMAN, ZION, UTAH

A slightly elevated viewpoint has helped to separate the foreground, middle distance and background elements of this landscape.

Leica R8, 35/2 Summicron, 1/125 sec at f5.6/8, Ektachrome 100 SW

further away with a long telephoto, the background subject area included is less but on a much larger scale, so much so that it sometimes appears overpowering. The perspective is flattened and often there is much less of a three-dimensional impression of depth in the picture.

Thus, by changing the lens and moving closer or further away the Leica user can change the appearance of the subject dramatically. Not only this, but the background can be used creatively. By moving in close with a wide angle, the photographer can keep the main subject large in the frame but also include a good amount of background which, albeit on a small scale, can clearly set the subject, be it wildflowers or an individual in their or its environment. With the telephoto, on the other hand, the background can be minimized so as not to draw attention away from the main subject.

Another useful technique is to look for a slightly higher viewpoint. You may have to move further away up a hill, stand on a wall or shoot from an upper-storey window, but a change of lens will maintain the correct amount of subject; the advantage of the higher viewpoint is that sometimes distracting

LITTLE MORETON HALL, CHESHIRE, ENGLAND
This delightful Elizabethan house belongs to the National Trust and is famous for its surrounding moat. The first shot is a conventional view with the 50mm Summicron. Moving in closer with the 19mm Elmarit enabled me to include the same image size for the house and also to include the moat.
Leica R8, 1/250 sec at f5.6/8, Ektachrome 100 SW

background can be eliminated and important middle distance detail that was previously hidden behind foreground objects can now be seen.

One of the great advantages of a Leica-quality 35mm system with a first-class choice of lenses is that it is easy to explore a variety of viewpoints and different perspectives of the same subject. You are not inhibited by having to use a tripod, a restricted film load or a limited range of lens options – so make the most of it!

CONVERGING VERTICALS

One perspective effect that can sometimes be annoying is the way that the converging verticals apparent when the camera is tilted upwards to photograph a tall building appear exaggerated and may even make the building appear to be leaning over backwards. Pictorially this can be quite dramatic, but for serious architectural photography it is important that verticals stay vertical! The range of 'R' lenses therefore includes a 28mm wide-angle with 'perspective control'. By shifting the vertical axis of the lens via a precision sliding mechanisim the camera

28mm F2.8 PC SUPER ANGULON R
The indicator scale and the micrometer drive for shifting the lens can be seen clearly at the rear of the lens mount.
Leica R8, 100/2.8 Apo Macro Elmarit, 1/30 sec at f16, Kodak T 400 CN

film-plane can be kept parallel with the subject so that the tilting that causes the convergence (or divergence if looking downwards) is avoided. The sliding mechanism can be set at other angles than the vertical so that other applications (for example, studio work and technical illustrations) are possible.

DEPTH OF FIELD

The area of an image within which the detail is acceptably sharp is the depth of field. Note the word acceptably: the only part of an image that is absolutely sharp is that on which the lens has been focused. All the rest is really an acceptable level of unsharpness!

Depth of field depends on the focal length of the lens, the distance away of the subject focused on and the aperture to which the lens is set. In simple terms, wide angle lenses provide the greatest depth of field and telephoto lenses the least. Examples for typical focal lengths are given on page 103.

Note the huge depth of field with very wide angle lenses and just how minimal this depth is with the long telephoto. With the reflex cameras, it is possible to preview the depth of field by using the stop-down lever. However, it is not always easy to judge the overall sharpness on the relatively small focusing screen dimmed by the stopping down, and it is sometimes much simpler to check the depth of field scale on the lens.

On the rangefinder cameras, the photographer has no choice but to rely on the depth of field scale and/or experience, but in critical situations the very positive rangefinder focusing does allow the near and far points of sharpness required to be established quickly and checked against the scale.

Bearing in mind the remarks above about 'acceptable unsharpness', my general practice is to work to 1 stop less tolerance than the depth-of-field scales allow. In other words, if, to cover a particular range of focus, the scale indicates that

CAERNARFON CASTLE, WALES
It was a great sky and I wanted to include a good proportion of it in the picture. The first effort involved tilting the camera, with the resulting inevitable converging verticals on the castle. By using around 5mm of shift on the PC lens, I was able to correct this in the second shot.
Leica R8, 28/2.8 PC Super Angulon, 1/60 sec at f8, Kodachrome 25 Professional

FLAGSTAFF, ARIZONA
Two quite different interpretations of the fall foliage near San Francisco Peaks. The steep perspective of the ultra wide angle compares with the flattened perspective of the zoom used near its longest focal length.
Leica R8, 19/2.8 Elmarit, 1/60 sec at f8, Kodachrome 25 Professional

Leica RE, 80–200 f4 Vario Elmar, 1/500 sec at f5.6, Ektachrome 100 SW

		at f2.8		at f11	
Lens	Focus distance (m)	From (m)	To (m)	From (m)	To (m)
21mm	5.00	2.46	inf	1.07	inf
	inf	4.74	inf	1.35	inf
35mm	5.00	3.60	8.00	2.00	inf
	inf	13.20	inf	3.40	inf
50mm	5.00	4.30	6.00	3.00	14.80
	inf	29.00	inf	7.40	inf
90mm	5.00	4.74	5.29	4.10	6.40
	inf	86.90	inf	22.10	inf
180mm	5.00	4.94	5.07	4.76	5.27
	inf	343.14	inf	85.93	inf
280mm	5.00	4.97	5.04	4.87	5.10
	inf	850.00	inf	214.00	inf
400mm	5.00	4.99	5.01	4.93	5.07
	inf	1760.00	inf	440.00	inf

DEPTH OF FIELD

stopping down to f5.6 is required, I would stop down to f8.

The minimal depth of field available at wider apertures with longer focal length lenses can be used advantageously to ensure that a distracting background becomes an unrecognizable out-of-focus blur. Conversely, if maximum depth of field is required and the composition so allows, a wide angle lens is the easier route.

A couple of points worth mentioning are that, except in the close-up range, depth of field is not evenly distributed around the point of focus – there is always more behind than in front – and in the very close range it is image size ratio rather than the focal length of the lens that governs depth of field. The table on page 117 shows the depth of field for different scales of reproduction.

CASARES, ANDALUCIA, SPAIN
The great depth of field available with a wide angle lens enabled me to ensure that both foreground and background were adequately sharp at a medium aperture. The overall quality of the new ASPH lens can be seen in this shot. The M6/0.85 facilitates composition and focusing with its higher magnification viewfinder.
Leica M6/0.85, 35/2 Summicron-M ASPH, 1/125 sec at f5.6, Kodachrome 25 Professional

Chapter 8

CLOSE-UP WORK

CLOSE-UP EQUIPMENT
The various options for close-up photography with Leica R cameras are shown here. On the left is the 90mm f2 Summicron and next to it the Elpro 3 and the Macro Adapter. At the rear are the 60mm and 100mm Macro lenses. In front of the Bellows R unit are the 65mm f3.5 Elmar with adapter ring and the little 25mm f2 Photar with its adapters.
Leica R8, 100/2.8 Apo Macro Elmarit, 1/4 sec at f16, Kodak T 400 C

The importance of being able to adapt the Leica and its lenses for close-up photography was recognized at an early stage of the system's development. During the 1930s, many accessories were made available to enable lenses to focus closer than their normal minimum distance of 1m (3ft) or 1.5m (5ft). These included an accessory, the PLOOT reflex housing, that in 1935 made the rangefinder Leica the world's first 35mm single-lens reflex! Nevertheless, it was not until 1965 that Leica's first true single-lens reflex camera was introduced, and in the meantime many useful smaller accessories as well as improved reflex housings and bellows units were produced for the rangefinder system. Inevitably, as the Leica single-lens reflex camera system was expanded and refined the need for such adaptation of the rangefinder cameras, now the M series, was reduced, until eventually by the mid-1970s production had effectively ceased.

GROUND SQUIRREL, POINT LOBOS, CALIFORNIA
Many of the R system lenses focus relatively close unaided. The squirrel was remarkably unconcerned, despite my shooting from only about 60cm (2ft) away.
Leica R5, 90/2 Summicron, 1/25 sec at f5.6, Kodachrome 64 Professional

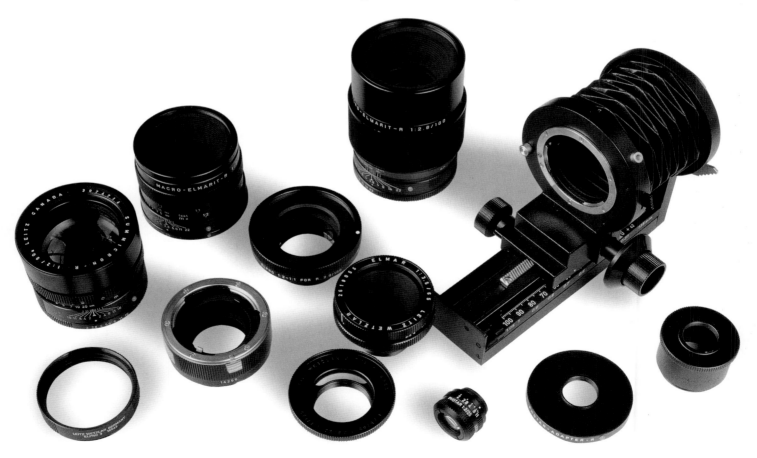

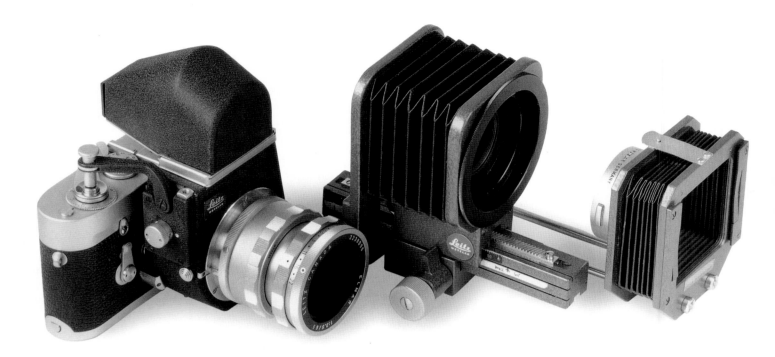

THE VISOFLEX

The Visoflex housings converted the M rangefinder Leicas into a very basic single-lens reflex. The earlier chrome version 65mm f3.5 Elmar is shown in the universal focusing mount that also takes the lens heads of the earlier 90mm f2.8 Elmarit and 135mm f4 Tele-Elmar. Many Visoflex lenses could also be used with the bellows unit shown here with its adjustable bellows lens hood.

Leica R8, 100/2.8 Apo Macro Elmarit, 1/4 sec at f16, Kodak T 400 CN

While there is no doubt that the Leicaflex and R series cameras are the most efficient and convenient approach to regular close-up photography, some of the later rangefinder items can be very practical for occasional use, even with the current M series cameras. They are fairly readily available secondhand in good condition, so I have included some detail on these as well as the R accessories.

R SYSTEM

CLOSE-UP ATTACHMENTS

A glance at the tables in earlier chapters will quickly show that the standard reflex lenses generally focus much closer than their rangefinder equivalents, so that without any special accessories it is possible to achieve very useful image ratios of 1:6 with a 90mm lens, for example, or even closer with the Vario Elmar zoom lenses – 1:3.9 with the 80–200mm and 1:2.9 with the 35–70mm. It should be remembered, however, that general purpose lenses such as these are not really designed for best performance with subjects in the close-up range and performance at such near distances, although remarkably good, especially with the lens stopped down say to f8 or smaller, will not compare with a macro lens specifically designed for such applications.

The Elpro close-up attachments that screw on like a filter and the Macro Adapter-R are convenient ways of extending the focusing range of many lenses. The most convenient combinations are set out in the tables on pages 114 and 115.

HONG KONG FLOWER

I did not have a macro lens with me on this trip, but the Elpro 3 used on the 90mm lens was perfectly adequate for my close-up requirements. The Elpro is a well corrected two-element achromat, providing excellent quality at medium apertures.

Leica R4, 90/2 Summicron + Elpro 3, 1/125 sec at f5.6, Kodachrome 64 Professional

ICICLES ON BEECH HEDGE

The Vario Elmars feature very good close focusing. This was taken at around the 1:6 ratio.

Leica RE, 28–70/3.5/4.5 Vario Elmar, 1/125 sec at f8, Kodachrome 200 Professional

VEINED WHITE BUTTERFLY

The extra working distance that the 100mm lens allows is very convenient for skittish subjects like butterflies.

Leica RE, 100/2.8 Apo Macro Elmarit, 1/60 sec f8, Kodachrome 64 Professional

INDIAN PAINT BRUSH, WYOMING, USA

A relatively easy subject for the 60mm Macro Elmar. I used a fairly wide aperture to keep intrusive background and foreground elements out of focus.

Leica R5, 60/2.8 Macro Elmar, 1/125 sec at f5.6/8, Kodachrome 64 Professional

Elpro lenses are of two-element construction and provide quite good correction and image quality at apertures even as wide as f5.6. I have found the Elpro 3 with a 90mm Elmarit or Summicron to be a particularly good combination.

Although the Macro Adapter-R (or the three-part extension ring set) can be used with any lens to allow closer focusing, it should be remembered that some lenses, especially the wide angles or very wide aperture lenses such as the Summilux, are unsuitable for close work. With some other lenses, like the zooms and certain Apo lenses, the corrections depend on maintaining the normal back focus. This is why the Apo Macro Elmarit does not use the Macro Adapter-R but has its own special multi-element Elpro attachment to extend its standard focusing range. With the zooms, if you do use the Macro Adapter-R, note that any change of focal length will require the lens to be refocused.

MACRO LENSES

Currently, two macro lenses are available: the 60mm f2.8 Elmarit and the 100mm f2.8 Apo Macro Elmarit. Both focus from infinity to half life-size (1:2). With the Macro Adapter, the 60mm will focus to life-size (1:1). The 100mm has to use its own special Elpro lens attachment that takes it to just over life size (1.1:1). Both lenses are excellent performers throughout their entire range, with a flat field and no discernible distortion. The 100mm especially is considered to be one of Leica's finest R lenses and is extremely versatile. It is a medium telephoto of exceptional quality, ideal for portraiture and landscape photography, as well as being outstanding for all types of close-ups. The extra working distance compared with the 60mm is a great advantage when photographing butterflies and other insects, although sometimes not so convenient for copying work.

BELLOWS UNITS

The Bellows BR2 unit replaced the former Bellows R unit in 1992. The main advantage of the new unit is that it maintains the connection between the R camera's body and the automatic diaphragm of Leica R lenses. For much serious close-up photography, the bellows units are highly desirable. As well as the normal R lenses, many other lenses and lens heads can be fitted. These include the 100mm f4 Macro Elmar, specifically designed for use with the bellows units, that allows focusing from infinity to life-size, and the three Photar lenses, specially computed for high magnification ratios. The tables indicate the appropriate range for each of these lenses. In addition, with various adapters many of the lenses from the rangefinder Visoflex system can be used. A particular favourite of mine is the 65mm f3.5 Elmar, which focuses from infinity to 1½x life size on the Bellows R. The Photars and the Visoflex lenses do not have automatic diaphragms so they have to be stopped down manually after focusing, but with the relatively static subjects involved this is rarely a problem.

RANGEFINDER SYSTEM

As indicated earlier, there have been numerous small accessories
to facilitate closer focusing with rangefinder lenses. They are
fascinating to use and wonderful examples of precision
engineering, but for convenience and accuracy they cannot
compare with reflex focusing. The reflex housings from the
PLOOT through to the Visoflex III greatly facilitate close-up
photography with the screw-mount and M series Leicas and are
still practical, albeit somewhat cumbersome to use compared
with an R camera. As well as the lenses made specifically for use
on the reflex housings, such as the early Telyts and the notable
65mm Elmar, the lens heads of many earlier 90mm and 135mm
lenses can be detached from their normal focusing mount and
fitted to one suitable for focusing from infinity to close-up.
Lenses in their normal rangefinder mount will work only in the
close-up range. Bellows units were made for the reflex housings,
together with suitable adapters to fit the various lens heads.

The two late model copying gauges 16511 and the 16526
(BOOWU) are also extremely convenient devices to use even
with current M cameras. The former takes any 50mm lens (the
Elmar and the Summicron are best, the Summilux and Noctilux
not good at close range) fitted to a series of tubes that allow
focusing at set sizes of 1:1, 1:1.5, 1:2 and 1:3. Masks are fitted
to the base to outline the field of view and focusing is carried
out on the ground-glass screen of a magnifier attachment,
which is then removed and replaced by the camera body.

WOOD TEXTURE

Close-up photography is a particular strength of the Leica reflex system with a number of effective approaches. The 100mm Apo-Macro lens used here not only excels in the close-up field but is a first class general purpose medium telephoto.

Leica RE, 100/2.8 Apo-Macro, Ektachrome 100SW, 1/250 sec f8

The 16526 is a set of four adjustable legs that can be set for A4, A5 or A6 size (actually very slightly longer). The legs are marked to indicate the correct extension for each size and then screwed into the appropriate attachment, which fits into the camera like a lens and acts as an extension tube. The lens, a collapsible Elmar or Summicron, or the removable lens head from an earlier rigid Summicron fitted with adapter 16508, is then bayoneted into the attachment fitted to the camera body. Note that with the collapsible lenses it is the inner bayonet of the collapsed lens that is used, which precludes the fitting of the M6-J or current versions 11823/11831. The legs outline the field of view and the plane of focus.

With both copying gauges, the lens needs to be stopped down to at least f8 or f11. Metering can be carried out through the lens with the M6 or M5. For this purpose, a Kodak grey card is useful.

CLOSE-UP DEVICES FOR THE RANGEFINDER CAMERAS

The Leica IIf is shown with the NOOKY for the 50mm f3.5 Elmar, the IIIg with the ADVOO and the M6 with the 16507 (SOOKY-M). With an appropriate 50mm lens, they each enable rangefinder focusing to around 0.5m (19in). At the back is the 16511 copying stand that can be used with both M and screw-mount Leicas to achieve ratios from 1:3 to1:1 with 50mm lenses.

Leica R8, 100/2.8 Apo Macro Elmarit, 1/4 sec at f16, Kodak T 400 CN

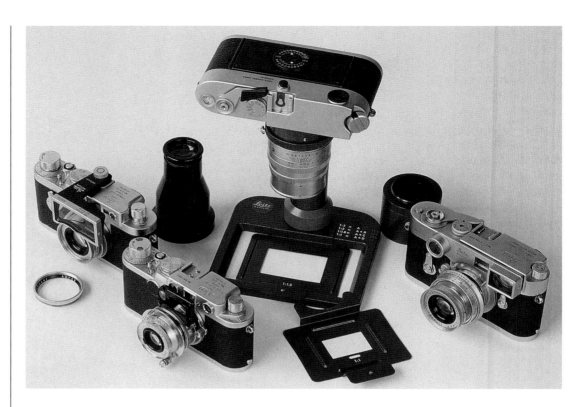

16526 (BOOWU-M) COPYING STAND

A most useful device for copying documents, brochures, maps and the like. The extension tubes and adjustable legs provide approximately A4, A5 and A6 sizes. The lens required is a collapsible 50/2 Summicron or 50/2.8 Elmar (but not the current model) or the removable lens head from an earlier rigid mount 50mm Summicron with adapter 16508.

Leica R8, 100/2.8 Apo Macro Elmarit, 1/4 sec at f16, Kodak T 400 CN

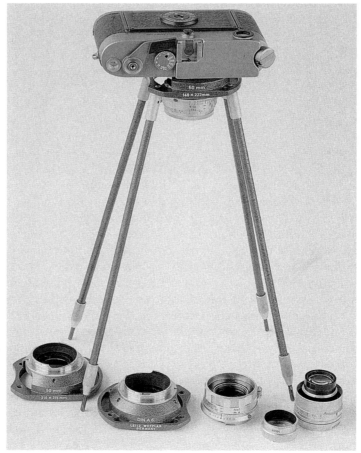

CLOSE-UP WITH SOOKY

The various close-focus devices for the rangefinder cameras illustrated above are suitable for occasional close-up work, although in practice a 90mm or 135mm lens at its closest focusing distance will achieve virtually the same image ratio. These travel guides were photographed at a distance of around 22 inches using the lens-head of a 50mm Summicron fitted to the SOOKY-M with a 16508 adapter.

Leica M6, 50/2 Summicron, 1/4 sec at f16, Ektachrome 100 SW

CLOSE UP WITH 16511 COPYING GAUGE

The 16511 outfit is extremely convenient for close-up copies of items such as postage stamps or, as here, part of the cover of the Michelin travel guide seen in the preceding picture. The TTL metering of the Leica M5 or M6 simplifies exposure calculations with both this and the 16526 (BOOWU-M) unit.

Leica M6, 50/2.8 Elmar, 1/4 sec f11, Ektachrome 100 SW

ELPRO CLOSE-FOCUS ATTACHMENTS FOR LEICA R LENSES						
Lens	ELPRO Code No.	Distance scale at	Distance in cm Object to film	Object to front lens	Object field in mm	Reproduction scale
SUMMICRON-R f/2/50 mm from	1 16541	∞ 0.5	50 31	41 21	184x276 91x137	1:7.7 1:3.8
No. 2777651 (E 55)	2 16542	∞ 0.5	30 24	21 14	94x141 62x93	1:3.9 1:2.6
SUMMICRON-R f/2/90 mm from No. 2770951 (E 55)	3 16543	∞ 0.7	74 44	61 30	161x241 72x108	1:6.7 1:3.0
ELMARIT-R f/2.8/90 mm from No. 2809001 (E 55)	3 16543	∞ 0.7	74 44	61 30	161x241 72x108	1:6.7 1:3.0
MACRO- ELMAR-R f/4/100 mm (E 55)	3 16543	∞ 0.6	75.5 41.6	61 24	145x218 48x72	1:6 1:2
	+ Macro- Adapter-R 14256	∞ 0.6	42 37.4	24 17	49x73 29x44	1:2 1:1.2
	4 16544	∞ 0.6	150.5 48.6	136 31	323x484 61x92	1:13 1:2.5
	+ Macro- Adapter-R 14256	∞ 0.6	48.8 40.4	31 20	63x94 34x51	1:2.6 1:1.4
APO-MACRO- ELMARIT-R f/2.8/100 mm	16545	∞ 1.2	35.4 30.5	16 10	49x73 22x33	1:2 1.1:1
ELMARIT-R f/2.8/135 mm from	3 16543	∞ 1.5	76 58	61 42	107x160 66x99	1:4.5 1:2.8
No. 2772619 (E 55)	4 16544	∞ 1.5	150 84	135 68	237x355 106x159	1:9.9 1:4.4

All values rounded off.

MACRO-ADAPTER-R
for LEICA R models (preferably with aperture priority and manual mode)

Lens	Distance scale at (m or reproduction scale)	Distance object to front lens in cm	Reproduction scale	Object field in mm
SUMMICRON-R f/2/50 mm	∞	11.6	1:1.75	42x63
	0.5	9.9	1:1.42	34x51
MACRO-ELMARIT-R f/2.8/60 mm	∞	16	1:2	48x72
	1:2	9.7	1:1	24x36
SUMMICRON-R f/2/90 mm	∞	32	1:3	72x108
ELMARIT-R f/2.8/90 mm	0.7	23	1:2	48x72
MACRO-ELMAR-R f/4/100 mm	∞	42	1:3.3	80x120
	0.6	25	1:1.6	39x59
ELMARIT-R f/2.8/135 mm	∞	75	1:4.5	108x162
	1.5	55	1:3	72x108
ELMARIT-R f/2.8/180 mm	∞	124	1:6	144x216
	1.8	78.4	1:3.4	82x123
APO-TELYT-R f/3.4/180 mm	∞	133	1:6	144x216
	2.5	95.6	1:3.9	95x142
TELYT-R f/4/250 mm	∞	256	1:8.4	202x303
	1.7	99.1	1:2.9	70x105
TELYT-R f/4.8/350 mm	∞	477	1:11.6	278x417
	3.0	178	1:4.1	97x146

RING COMBINATION FOR THE CLOSE-FOCUS RANGE
for LEICA R models (preferably with aperture priority and manual mode) and LEICAFLEX SL/SL2 models

Lens	Distance scale at	2-part (height 25 mm) 14 158			3-part (height 50 mm) 14 159		
		Distance object to front lens cm	Reproduction scale	Object field mm	Distance object to front lens cm	Reproduction scale	Object field mm
SUMMICRON-R f/2/50 mm	∞	13.5	1:2.1	50x75	8.1	1:1.04	25x37
	0.5	11.2	1:1.6	38x58	7.5	1.09:1	22x33
SUMMICRON-R f/2/90 mm	∞	37.6	1:3.6	86x130	21.4	1:1.8	43x65
ELMARIT-R f/2.8/90 mm	0.7	25.2	1:2.2	53x79	17.6	1:1.4	34x50
ELMARIT-R f/2.8/135 mm	∞	87.2	1:5.4	130x195	50.7	1:2.7	65x97
	1.5	59.7	1:3.4	81x121	42.3	1:2.1	50x75
ELMARIT-R f/2.8/180 mm	∞	146	1:7.2	172x258	81.2	1:3.6	86x129
	1.8	84.9	1:3.8	91x137	61.3	1:2.5	60x90
APO-TELYT-R f/3.4/180 mm	∞	154	1:7.2	172x258	89.4	1:3.6	86x129
	2.5	104	1:4.4	106x159	74.0	1:2.7	66x99
TELYT-R f/4/250 mm	∞	299	1:10.1	242x363	172	1:5.0	121x181
	1.7	104	1:3.2	76x114	85.8	1:2.3	55x82
TELYT-R f/4.8/350 mm	∞	558	1:13.9	334x501	316	1:7.0	167x250
	3.0	187	1:4.4	105x157	153	1:3.2	76x114

All values rounded off.

LEICA R LENSES ON FOCUSSING BELLOWS BR 2

Lens	Reproduction scale	Distance object to front lens cm	Object Field mm	Comment
SUMMICRON-R 50/2	1:1–3.2:1	6.0–2.4	24x36–7.5x11.3	
MACRO-ELMARIT-R 60/2.8	1:1.2–3.2:1	7.2–2.2	29x43–7.5x11.3	
SUMMICRON-R 90/2	1:1.7–2:1	21–10	41x61–12x18	
ELMARIT-R 90/2.8	1:1.7–2:1	21–10	41x61–12x18	
MACRO-ELMAR 100/4 (lens head)	inf–1.1:1	inf–15	inf–22x33	
MACRO-ELMAR-R 100/4 (focussing mount)	1:1.9–1.9:1	26–12	46x68–13x19	
ELMARIT-R 135/2.8	1:2.6–1.3:1	48–23	62x94–18x28	

PHOTAR LENSES ON FOCUSSING BELLOWS BR 2

Lens	Reproduction scale	Distance object to front lens cm	Object Field mm	Comment
PHOTAR 12.5/2	8.5:1–17.5:1	0.9–0.8	2.8x4.2–1.4x2.1	lens code 549025
PHOTAR 25/2	3.5:1–7.5:1	2.0–1.5	6.8x10.2–3.2x4.8	lens code 549026
PHOTAR 50/4	1.4:1–3.4:1	8.1–6.0	17x25.5–7x10.5	lens code 549027

LEICA R LENSES ON FOCUSSING BELLOWS R

Lens	Reproduction scale	Distance object to front lens cm	Object Field mm	Comment
SUMMICRON-R 50/2	1:1.2–2.9:1	9.1–4.5	30x45–8.4x12.5	
MACRO-ELMARIT-R 60/2.8	1:1.5–2.8:1	12.5–5.7	35x53–13.7x20.6	
SUMMICRON-R 90/2	1:2.1–1.8:1	24.5–10.4	51x76.5–13.7x20.6	
ELMARIT-R 90/2.8	1:2.1–1.8:1	24.5–10.4	51x76.5–13.7x20.6	
MACRO-ELMAR 100/4 (lens head)	inf–1:1	inf–18.7	inf–24x36	
MACRO-ELMAR-R 100/4 (focussing mount)	1:2.4–1.7:1	32.6–14.7	57x85.5–14.2x21.3	
ELMARIT-R 135/2.8	1:3.2–1.2:1	58–26	77x115.5–20.6x30.9	

LEICA VISOFLEX LENSES ON FOCUSSING BELLOWS R

Lens	Reproduction scale	Distance object to front lens cm	Object Field mm	Comment
ELMAR V 65/3.5	inf–1.5:1	inf–10.5	inf–16x24	with adapter 16863
ELMARIT M 90/2.8 (lens head)	inf–1.1:1	inf–13.5	inf–22x33	with adapter 16863
TELE-ELMAR M	inf–1:1.3	inf–36	inf–32x48	with adapter 16863

PHOTAR LENSES ON FOCUSSING BELLOWS R				
Lens	Reproduction scale	Distance object to front lens cm	Object Field mm	Comment
PHOTAR 12.5/2	7.5:1–15.5:1	0.8–0.7	3.2x4.8–1.55x2.32	lens code 549025
PHOTAR 25/2	3:1–7:1	2.2–1.7	8x12–3.5x5.2	lens code 549026
PHOTAR 50/4	1.2:1–3.2:1	8.8–5.9	20x30–7.5x11.2	lens code 549027

DEPTH-OF-FIELD RANGE AT REPRODUCTION SCALES FROM 1:20 TO 10:1
The round values are based on a circle of confusion of 1/30mm.

Reproduction scale	Magnification	Extension factor with exit:entry pupil ratio 1:1	Depth of field in mm				
			f/4	f/5.6	f/8	f/11	f/16
1:20	0.05	1.1x	110	154	220	308	440
1:15	0.067	1.1x	65	90	130	180	260
1:10	0.1	1.2x	30	40	60	80	120
1:5	0.2	1.4x	8	10	15	20	30
1:4	0.25	1.6x	5.5	7.5	11	15	22
1:3	0.33	1.8x	3	4.5	6	9	12
1:2	0.5	2.3x	1.5	2	3	4	6
1:1.5	0.67	2.8x	1	1.4	2	2.7	4
1:1	1	4x	0.5	0.7	1	1.4	2
1.5:1	1.5	6.3x	0.3	0.4	0.6	0.8	1
2:1	2	9x	0.2	0.3	0.4	0.6	0.8
3:1	3	16x	0.1	0.2	0.25	0.35	0.5
4:1	4	25x	0.08	0.12	0.16	0.23	0.32
5:1	5	36x	0.06	0.09	0.13	0.18	0.26
6:1	6	49x	0.05	0.07	0.10	0.14	0.20
7:1	7	64x	0.04	0.06	0.09	0.12	0.17
8:1	8	81x	0.04	0.05	0.08	0.10	0.15
9:1	9	100x	0.03	0.05	0.07	0.09	0.13
10:1	10	121x	0.03	0.04	0.06	0.08	0.12

Chapter 9

GETTING THE BEST FROM YOUR LEICA LENSES

Having invested in some of the world's best lenses, it would be a shame not to achieve the very best of which they are capable. All that wonderful tonal quality and colour rendition, as well as the sharpness of a Leica lens, can so easily be impaired by poor photographic technique. Fortunately, most photographers who buy into one or other of the Leica systems already have an accomplished camera technique. What follows is a reminder of some of the more important general considerations, together with a few points specific to the Leica. The essential elements that contribute to a quality image are:

• Accurate focusing
• Avoidance of camera shake
• Avoidance of subject movement
• The right film
• Correct exposure

AGUA CANYON, BRYCE, UTAH
Wonderful light and a high-quality film help a first-class lens to achieve its potential. **Leica RE, 21/4 Super Angulon, 1/125 sec at f5.6/8, Kodachrome 25 Professional**

CONCORDE
Avoiding movement blur and camera shake, especially when magnified by a longer focal length lens, are key factors in the drive for best image quality. Both elements were present here, as well as a requirement for very accurate focusing. **Leica RE, 280/2.8 Apo Telyt, 1/1000 sec at f5.6, Fuji Provia 100**

PRINCES RISBOROUGH, BUCKINGHAMSHIRE, ENGLAND

Exposure here had to be very precise in order to hold detail throughout the image.
Leica M6, 28/2.8 Elmarit, 1/60 sec at f4/5.6, Kodachrome 25 Professional

On a more mundane level, it is also important that lenses and/or filters are kept clean. Dirt, rain spots and greasy smudges on the front or rear elements of lenses or on filters can seriously affect performance – more so than a small scratch. See Chapter 11 page 150 for advice on cleaning.

ACCURATE FOCUSING

Obviously, there is no way that a subject can be rendered sharply if the lens is not focused accurately. Do take care with focusing – do not rely on depth of field to cover errors. As explained in Chapter 7, depth of field is no more than an acceptable degree of unsharpness!

It is important that you can see the focusing screen or the rangefinder patch clearly. This means having the ability to focus the eye at the virtual distance of the viewfinder image (around 1m/3ft) and many people, especially as they get older, cannot do this. With the M series Leicas and reflex cameras up to and including the R4 there is no built-in dioptre adjustment of the viewfinder, so you must either wear your spectacles or buy a suitable correction lens to fit the camera eyepiece. Leica supply these through their dealers, who will be able to advise on the appropriate correction lens. Leica also supply frames into which your optician can fit prescription correction lenses for other vision defects such as astigmatism.

The screw-mount rangefinder models have limited adjustment and the R models from R5 onwards do have +2 to -2 dioptre adjustment in the viewfinder, which is adequate for

HOVERFLY
Apart from critical focusing, the major problem with close-ups of insects and other tiny subjects outdoors is movement blur, either from the subject itself or caused by wind disturbance. Electronic flash, with an effective speed of 1/1000 sec or even faster, helps to combat this and provides enough light for smaller apertures.
Leica R5, 100/2.8 Apo Macro Elmarit, 1/60 sec at f11/16, Kodachrome 25 Professional

most people. The R8 also has a high eyepoint finder which makes it much easier for spectacle wearers to see the whole screen.

With the M cameras it is not easy to see the full viewfinder when wearing glasses. With later cameras – M4P and M6 – the 28mm frame in particular is difficult to see. For this reason, fitting a correction lens to the viewfinder may be the best option for some M users. It is also important with the M cameras to centre the eye properly to the viewfinder in order to avoid any possible error when using the rangefinder with longer focal length lenses.

With the R4 and later cameras there is a choice of focusing screens other than the standard split image/microprism-doughnut. For close-up work and when using long focal length lenses, a plain ground-glass screen is recommended. This is also available with a grid pattern that can be helpful with composition or when shooting architectural subjects. This is the screen that I now use as standard.

As with lenses, it is important to keep the viewfinder eyepiece clean and free from greasy smudges. This applies also to the front viewfinder and rangefinder windows on the M and screw-mount models. Use the microfibre cloth recommended on page 150.

CAMERA SHAKE

The only reasonably sure way of avoiding camera shake is always to use the camera on a good, strong tripod. While this is necessary for some studio and close-up work and photography with long, heavy lenses, it negates the important advantages of 35mm photography – a light, compact, portable system offering the ability to explore different viewpoints and perspectives easily with a variety of lenses and to work inconspicuously in available light.

BLUE EYES

The zoom was used around its maximum (200mm) focal length. The faster (ISO 100) film is ideal for use with longer lenses that require higher shutter speeds in order to avoid camera shake. On a cloudy day the qualities of the lens and film have combined to produce excellent sharpness and skin tones.

**Leica R8, 80–200/4 Elmar,
1/500 sec at f4,
Ektachrome 100 SW**

The alternative to a tripod is to ensure that, wherever light conditions permit, a sufficiently high shutter speed is used to minimize any camera movement. Most people are remarkably optimistic about their ability to hold a camera steady and the advice given in magazines often encourages such optimism. My rule of thumb for the minimum safe speed for hand-holding the various focal lengths is:

Up to 35mm focal length	1/125 sec
Up to 100mm	1/250 sec
Up to 200mm	1/500 sec
Over 200mm	1/1000 sec

Certainly, if the picture is important and there is no alternative I will use slower speeds hand held (down to 1/8 sec sometimes with an M!), but I know that I am risking a less than 100 per cent sharp result. When hand holding at slow speeds there are ways of helping the situation. Pressing the camera on or against a wall or fence to help steady it is one method; resting your elbows on, or wedging your shoulder against, something firm can also help, particularly when you have to drop to lower speeds with longer lenses.

For my travel photography, I often take along the Leica table tripod. This takes up very little space, and with a bit of ingenuity in finding a suitable surface for support it can be invaluable for night views and interiors. For close-up and long shots with Leica lenses, some photographers find that a monopod enables them to work at lower shutter speeds, offering a much lighter, more compact and portable alternative to a tripod.

When you choose a tripod, do look for a really good, solidly made one. For what it's worth, my choice is the rather idiosyncratic Benbo, used with the large Leica ball-and-socket head. Long exposures and close-ups with a tripod demand a smooth release of the shutter in order to avoid setting off unwanted vibrations. Use a decent length cable release and if possible the mirror lock-up on later R cameras. An alternative to the cable release is to use the camera delayed action.

SUBJECT MOVEMENT

Faces twitching, people walking, plants blowing in the breeze, cars racing and aircraft flying – subject movement is an often unrecognized cause of imperfectly sharp pictures. On the whole, the minimum speeds I have recommended above will deal with most normal situations, but particularly rapid movement will need additional consideration. Close pictures with a wide angle lens of, say, a horse jumping a fence, would still need 1/500 sec or 1/1000 sec to stop the movement. With aircraft photographed sideways on, some degree of 'panning' is needed even at 1/1000 sec: a Boeing 767 landing at around 150mph moves 8cm in 1/1000 sec!

Particular problems occur with outdoor close-ups of plants and insects. The slightest breath of wind not only causes movement that is exaggerated due to the high magnification but may also move the subject away from the focused point. Some sort of windbreak outside the picture area is worth trying and remember, too, that early morning and evening usually offer calmer conditions.

FOLLOWING PAGES
FALL COLOURS, ZION, UTAH
Shooting with a very bright sun shining directly into it can cause problems for any lens. By partially hiding the sun behind the tree branch, the risk of reflections was much reduced.
Leica R8, 19/2.8 Elmarit, 1/125 sec at f8, Kodachrome 25 Professional

CAMERA SUPPORT
The Leica table tripod can be fitted easily into a gadget bag and is a compact, portable option that will help to steady the camera when a heavy-duty tripod is not practical.
Leica R8, 100/2.8 Apo Macro Elmarit, 1/4 sec at f16, Kodak T 400 CN

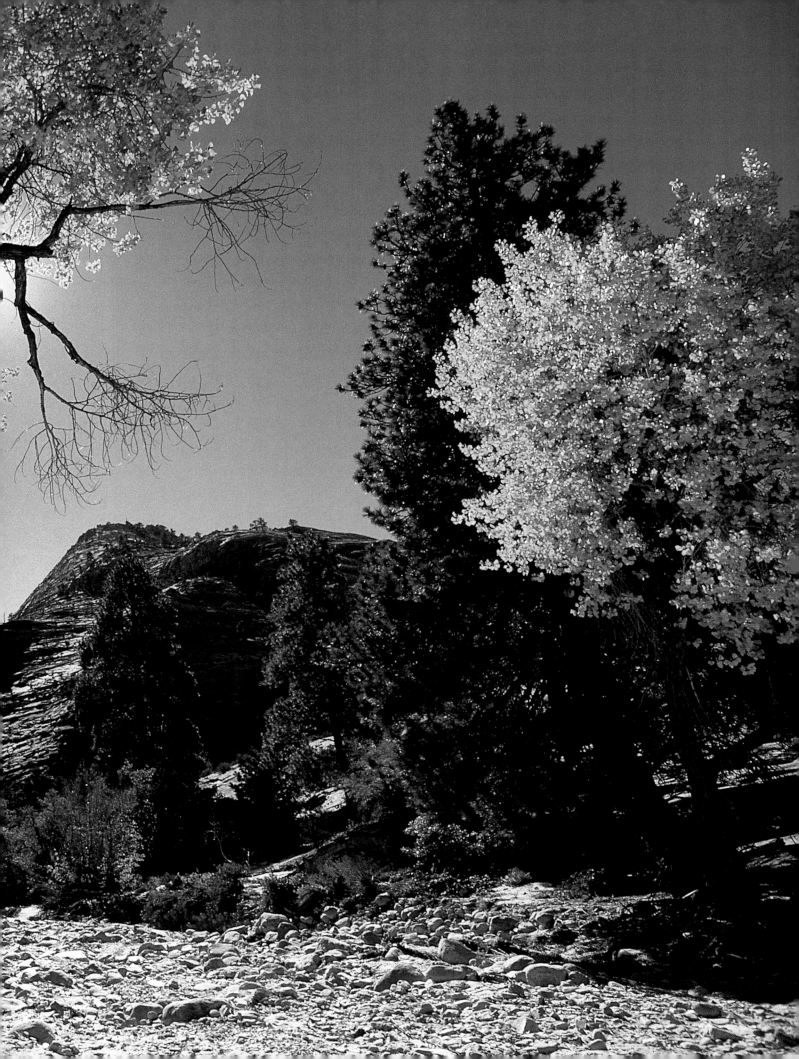

FILM

To get absolute best quality from your lens together with the best possible tonal quality you need the very sharpest, finest-grained films. Whether monochrome, colour negative or colour transparency, these films are always the slowest speed. With colour transparency this means film such as Kodachrome 25 and Fuji Velvia, ISO 25 and ISO 50 respectively. With negative films, colour or monochrome, the ISO 100 films from the leading manufacturers are the relevant ones.

Nevertheless, over recent years there have been tremendous improvements in all films and the quality available from ISO 100 transparency films such as Ektachrome 100 SW or Fuji Provia, for example, is remarkable. In the case of black and white, the same is also true of ISO 400 films.

Obviously, the subject matter and lighting conditions will often be the major factors when choosing a film. I mainly shoot colour transparency and if at all possible I like to use Kodachrome 25. This is fine for subjects in good light with lenses up to 90mm. Often, even the 135mm f4 can be used on a sunny day – I can just manage my basic exposure for an aircraft shot of 1/500 sec at f4. Using the same film, a landscape taken with a 35mm lens would be around 1/125 sec at between f5.6 and f8, so that adequate depth of field is available even with a relatively near foreground.

Close-ups, long lenses, action photography and poor light usually call for faster films. In the majority of instances ISO 100 is fast enough. My current favourite at this speed is Kodak Ektachrome 100 SW, which permits 1/1000 sec at f5.6 or 1/500 sec at f8 in good daylight. The only other transparency film I use regularly is Kodachrome 200. The extra speed is often useful and this film is great for mixed lighting such as night scenes outdoors or theatre photography. It is very sharp but obviously grainier than the slower films.

Enthusiasts for black and white photography will have their own favourite films and developers. One that I have recently found convenient is Kodak T Max T400 CN. This film is very tolerant on exposure and is C41 process, the same as colour negative film, so that if necessary you can get results quickly from a mini-lab. It is sharp, with fine grain and quite good tonal quality. Of the slower films, Ilford Delta 100 has given me excellent results and received many good reports.

EXPOSURE

For best quality, especially with colour transparency films, correct exposure is essential. Over-exposure will lose highlight details, under-exposure loses shadow detail. Variations of even 1/2 stop can make a significant difference, so use your meter intelligently; with any seriously important subjects bracket exposures +/- 1/2 stop, and with a really tricky subject (against

BRITTANY, FRANCE

If you need sharpness from foreground to the far distance, care is needed to ensure adequate depth of field. In the first shot the focus is on the boat. Even at a medium aperture the cottages in the distance are unsharp. For the second shot I checked with the depth of field scale to see what aperture was required, to ensure that both the cottages and boat would be in focus. Very nearly the minimum stop available was needed!

Leica M6, 50/2 Summicron, Ektachrome

1/500 sec at f5.6/8

1/125 sec at f11/16

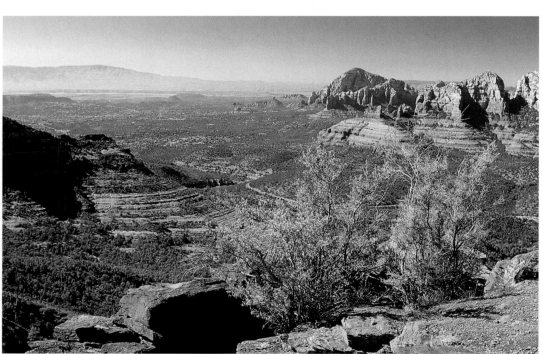

SEDONA, ARIZONA
As well as having the sometimes convenient effect of intensifying an unduly pale blue sky, a polarizer will often help to clear haze and blueness in the distance. The effect on Sedona's famous red rocks is dramatic.
Leica R8, 35/2 Summicron, Ektachrome 100 SW

Without polarizer, 1/250 sec at f8

With polarizer, 1/125 sec at f5.6/f8

the light, say) +/- 1 stop too. Film is cheap, good opportunities infrequent!

Negative films, colour or monochrome, are usually a little more tolerant, and in any case some compensation is possible at the printing stage. Bracketing +/- 1 stop is still worthwhile and it is usually best to err slightly on the generous side with exposures so as to ensure good shadow detail.

RUST
Lenses are optimized for different purposes. Of the 50mm rangefinder lenses, the Summicron and the Elmar perform well in the close-up range, the higher speed Summilux and Noctilux less so. The camera here was about 1m (40in) from the subject and through careful alignment there was sufficient depth of field at quite a wide stop.
Leica M6, 50/2 Summicron, 1/60 sec at f4/5.6, Kodachrome 25 Professional

PREVIOUS PAGE ROYAL PALACE, BANGKOK, THAILAND
The 28mm lens provided ample depth of field and excellent detail with the slow, fine-grain film.
Leica R4, 28/2.8 Elmarit, 1/60 sec at f8, Kodachrome 25

FILTERS

If, like me, you always keep a filter on your lens, do buy good quality ones. Leica have their own range, of course, but this is somewhat limited. B & W Filters (part of the Schneider Kreuznach group) offer an excellent range that includes some of the hard-to-get Leica sizes such as E39 or E60. Minolta (55mm and 72mm) and Pentax (77mm) filters are also good quality. My preferred general filter is a Wratten 1A equivalent. This is the proper Skylight filter and is a pale pinky-straw colour. The B & W Skylight KR 1.5 is the correct one. Many makes of Skylight filters are too magenta.

After careful comparison, I have never seen any noticeable loss of lens quality when using a good quality filter, although in theory no doubt there should be! Do keep the filter clean, though.

OPTIMUM APERTURE

All Leica lenses can confidently be used at their maximum aperture and will give excellent quality at all stops, maximum or minimum. With faster lenses – f1, f1.4 and f2 – stopping down shows improvement in image quality at the edges and brings any mechanical vignetting under control. Taking all factors into account – central definition, edge definition, vignetting and so

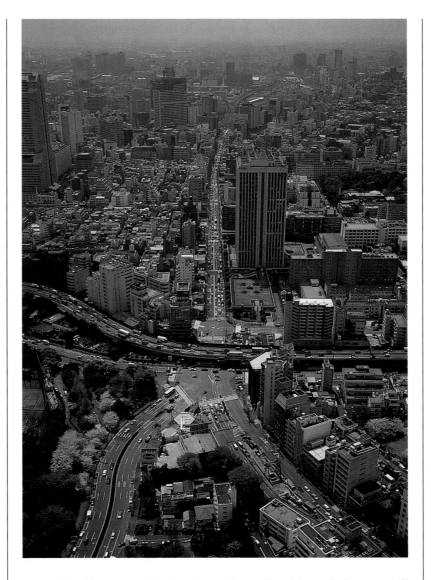

TOKYO, JAPAN
Most Leica lenses are already at their optimum aperture by around f4/5.6. This applies also to the later wide angle lenses, as this picture taken from the Tokyo Tower shows.
Leica M6, 35/2 Summicron, 1/125 sec at f5.6, Kodachrome 25 Professional

on – the faster standard and medium focal length lenses will already be at their optimum around f4/f5.6. This will also apply to all the current ASPH wide angle lenses for the M and the 28mm f2.8. Generally, however, wide angle lenses need to be stopped down to f5.6 or f8 for absolutely critical edge definition.

The longer Apo lenses are a different story. They are pretty well at their best at full aperture: going down 1/2 or 1 stop might show a very slight improvement, but you would be hard pushed to detect it. The only real advantage in stopping down is improved depth of field.

With lenses of Leica quality, stopping down beyond about f8 is likely to show some slight reduction in performance compared with the very high levels at wider apertures. This is due to diffraction effects from the diaphragm. Unless depth of field considerations apply, use a higher shutter speed instead of stopping down.

CHOOSING AN OUTFIT

TOLEDO, SPAIN

The 21mm is the widest angle lens within the M system. A separate finder is required and it needs some practice to use effectively but it is great for panoramic views such as this and for dramatic perspectives. The latest ASPH version provides better edge definition and reduced system vignetting.

Leica M6/0.85, 21/2.8 Elmarit-M ASPH, 1/125 sec at f5.6, Kodachrome 25 Professional

Many Leica photographers are professionals or advanced amateur users, who come to the M or R system with more than enough knowledge to be able to determine exactly what kind of outfit they require to fulfil their specific needs. Others, perhaps less knowledgeable of the Leica systems or still exploring different aspects of photography, may find the following suggestions helpful when putting an outfit together.

LEICA M SYSTEM

The rangefinder cameras are outstanding performers when used in those subject areas most suited to them, but are much less versatile than the reflex system. For this reason, the range of lenses is far more restricted – the focal length range runs only

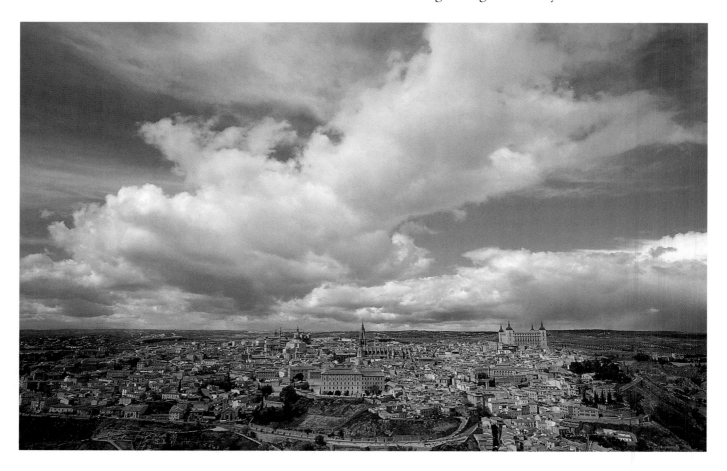

from 21mm to 135mm and there are no specialized lenses such as macro or perspective control. This might seem inhibiting, but in practice the range even from 35mm to 90mm will be found to cover a surprisingly high proportion of most photographers' normal requirements.

BASIC OUTFIT

The classic lens for the M is the 35mm. Most users would agree that this is the focal length you should not be without. Between the f2 Summicron ASPH and the f1.4 Summilux ASPH, I would opt for the Summicron. It is smaller, lighter and concedes nothing in performance. It is also cheaper.

If you really feel you will need f1.4 for some of your work, save this aperture for your standard (50mm) lens. While the 50mm Summicron is technically a better lens, you would be hard pressed to tell the difference when stopped down beyond f4, and in low-light situations the extra stop and higher contrast in the centre of the frame, as well as the greater freedom from reflections, are probably more important than the better corrections and edge definition of the Summicron. As far as the Noctilux goes, while this is a phenomenal lens, it is big, heavy and conspicuous – not to say very expensive. I would not consider this lens until I was very sure that it was really needed.

To complete the basic outfit, a 90mm lens is desirable. This will enable you to concentrate, when necessary, on the essentials of the subject, it is an ideal focal length for portraits and is as near as you get to close-up photography with an M.

LEICA M6 OUTFIT

An M6 with 35mm, 50mm and 90mm Summicron lenses is a very sound basic outfit that will cover many popular subjects and especially in those subject areas where the 'M' system has particular strengths.
Leica R8, 100/2.8 Apo-Macro, 1 sec at f22, Ektachrome 100SW

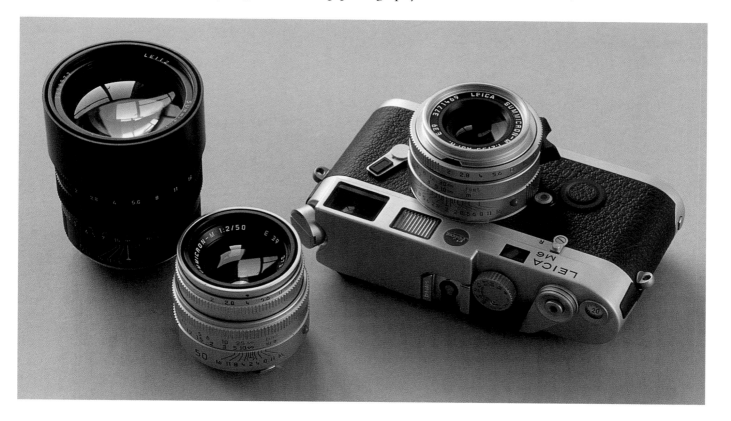

The 90mm facilitated a reasonably tight composition of this street scene.
Leica M6, 90/2 Summicron, 1/250 sec at f5.6, Kodachrome 64 Professional

Regent Street at Christmas, London
The 'M' is the ultimate available-light camera, so if it can be afforded it makes sense to have an f1.4 lens in the outfit!
Leica M6, 50/1.4 Summilux 1/30 sec at f1.4, Kodachrome 200 Professional

Surprisingly, there is little difference in weight between the f2 Summicron and the f2.8 Elmarit. My choice (cash permitting) would be the Summicron. Not only is the M *the* camera for available light, but the faster aperture is desirable to allow faster shutter speeds and to avoid camera shake with the longer focal length.

So, for me, the ideal basic outfit is:

35mm Summicron
50mm Summilux or Summicron
90mm Summicron

Keen climbers and walkers concerned about weight and portability would probably wish to consider the conveniences of the Tri-Elmar together maybe with a late version of the discontinued 90mm Tele-Elmarit. This would be an excellent option.

EXTENDED OUTFIT

To extend this outfit, I would opt first for a 21mm Elmarit ASPH. This focal length is a favourite with me and I would not want to be without it. The dynamic perspective effects are wonderful and the ability to work in confined spaces can be a real picture saver.

Next I would consider a 135mm. The new f3.4 Apo-Telyt would be first choice while, of the older lenses, the f4 Tele-Elmar offers high optical quality and compactness. However, although it is nice to have a longer lens available, in reality I find that only infrequently do I use anything longer than the 90mm with the M, and starting from scratch I would question whether

it would be better to spend the money on a second body rather than on a 135mm.

Similar considerations apply to the 24mm, 28mm and 75mm lenses. They may well suit a particular purpose better than those that I have suggested and they are all fine performers. Nevertheless, the 35mm/50mm/90mm combination is a classic that has stood the test of time and is a good starting point.

FOLLOWING PAGES
HONG KONG
The ubiquitous 35mm Summicron was the ideal lens for this early evening shot looking towards Victoria Peak from Kowloon.
Leica M6, 35/2 Summicron, 1/250 sec at f4, Kodachrome 25 Professional

LAS VEGAS, USA
The dramatic perspective from 21mm focal length was entirely appropriate for the amazing main entrance to the MGM Grand Hotel.
Leica M6, 21/2.8 Elmarit, 1/125 sec at f5.6, Kodachrome 25 Professional

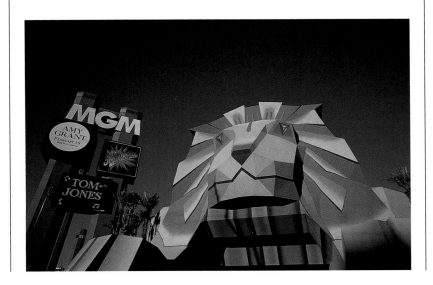

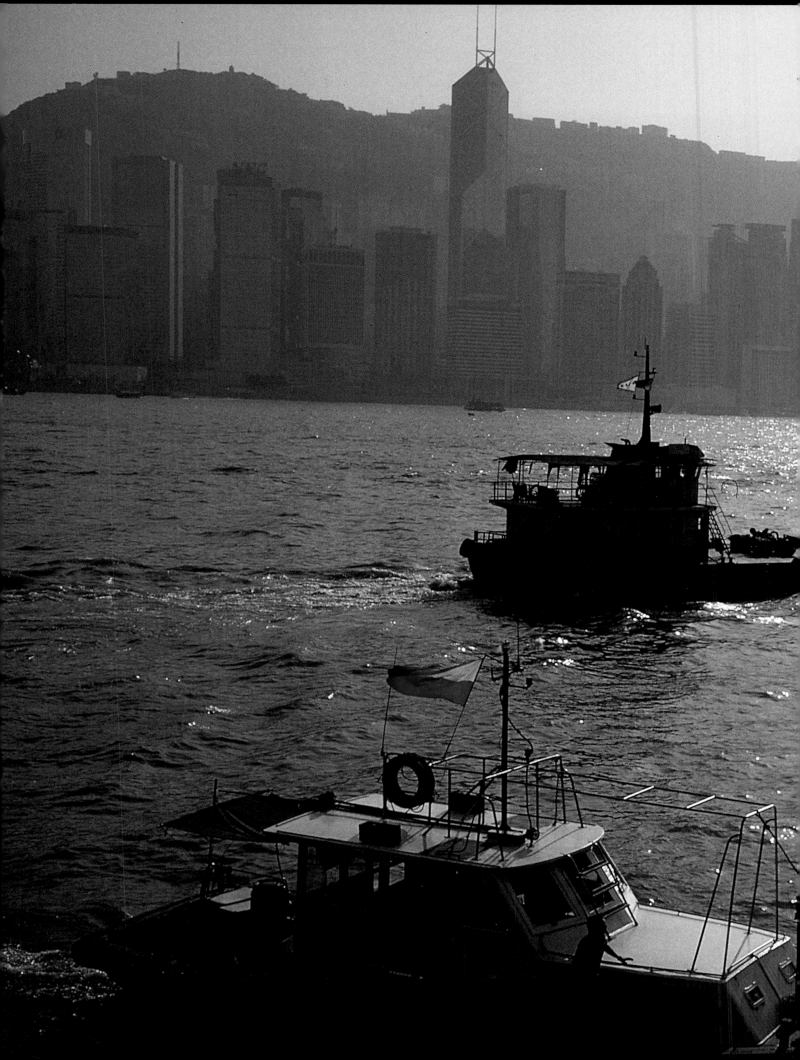

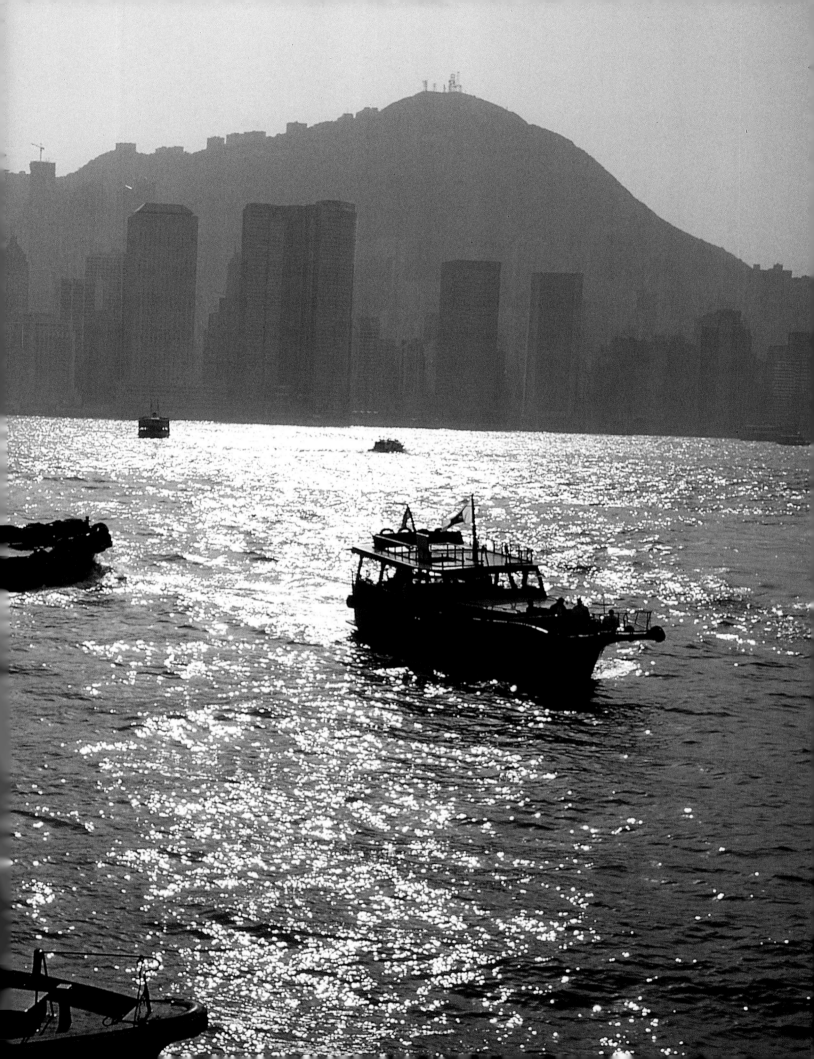

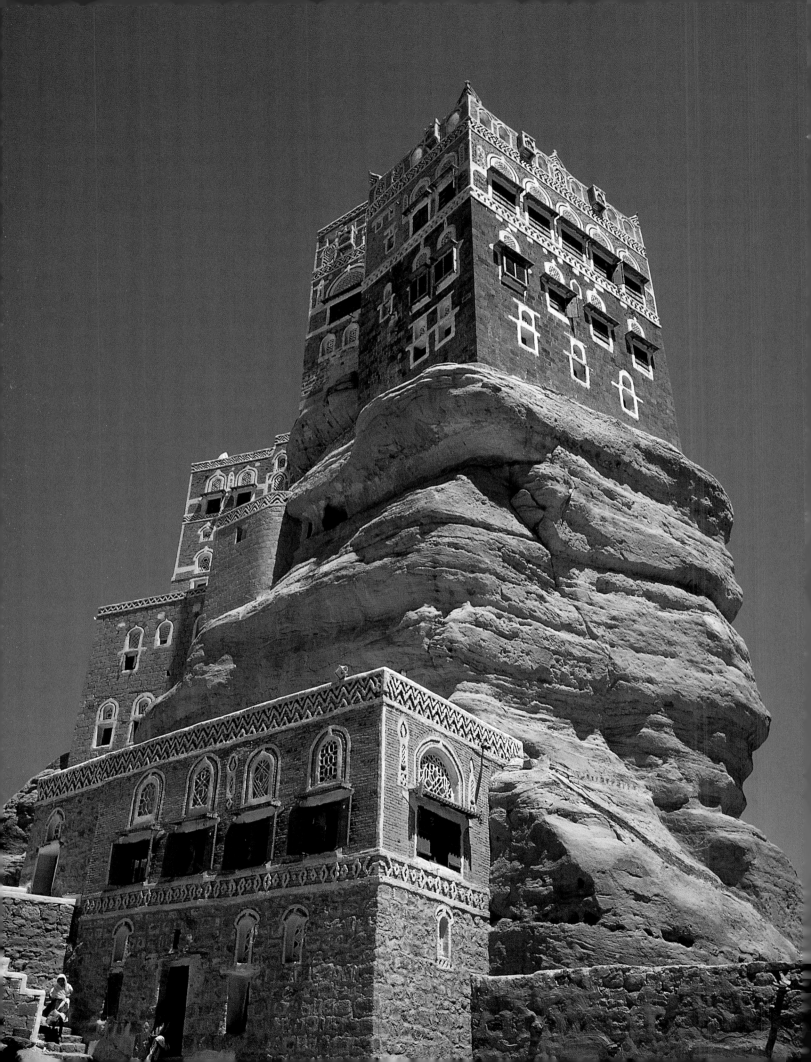

THE ROCK PALACE,
WADI DHAHR, YEMEN
An M6 with a 35mm
Summicron is the core of an
ideal outfit for travelling to
interesting places off the
beaten track. The Yemen is
fascinating.
Leica M6, 35/2 Summicron,
1/250 sec at f4/5.6,
Kodachrome 25
Professional

LEICA R SYSTEM

The choice here is much more diverse and complex. Initially, until you are clear in which direction your photographic interests will lie it is important to keep options open, selecting lenses that can be expected to fit in with a variety of long-term needs.

PRIME LENSES V ZOOM LENSES

In terms of general photography, the first step is to decide between prime lenses and zoom lenses. A governing factor is likely to be the need for wider apertures. If you expect to work in low light or with slow, high-quality films such as Kodachrome 25 or Fuji Velvia, the prime lenses with their higher lens speed are desirable. The penalty is more lenses and more weight to cover a given range of focal lengths.

The convenience of zooms is undoubted and the quality of the latest range of Vario lenses from the Solms design office is close enough to prime lens standards for a basic outfit based on the 35–70mm and 80–200mm lenses to be both versatile and practical. The advantage of the 35–70mm as against the 28–70mm is mainly the better close-up facility (1:2.9 at macro setting) and the constant f4 aperture. If the 28mm wide angle setting is more useful, then go for the 28–70mm with the 80–200mm.

For a prime lens outfit, I would start with a two-lens combination of a moderate wide angle and a medium telephoto. This would be either the 28mm f2.8 Elmarit or the 35mm f2 Summicron, together with any one of the 80mm f1.4 Summilux, 90mm f2 Summicron or 100mm f2.8 Apo Macro

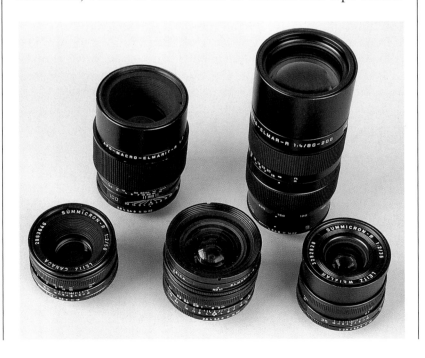

LEICA R OUTFIT
When I am using the reflex system, these are the lenses that I regularly carry.
FRONT ROW: 50/2 Summicron, 19/2.8 Elmarit, 35/2 Summicron.
BACK ROW: 100/2.8 Apo Macro Elmarit, 80–200/4 Vario Elmar. Other lenses are only included to meet a specific need.
Leica R8, 60/2.8 Macro, 1/4 sec at f16, Ektachrome 100 SW

Elmarit. The 35mm f2 and 100mm f2.8 are two of my all-time favourite Leica lenses, so these would be my personal choice, but any of the combinations would be good and form the core of a versatile outfit that could be extended to cover many specialist areas.

One of my reasons for choosing the 35mm lens is that I have an interest in architectural photography and eventually acquired a 28mm f2.8 PC Super Angulon. If you have this possibility in mind, it is logical to go for the 35mm Summicron. Another reason is that, with hindsight, I realize that I rarely use the 50mm lens with the reflex system, so the 35mm Summicron becomes my fast standard lens. I would choose the 100mm f2.8 over the 80mm and 90mm lenses because of an interest in close-up photography – the Apo Macro serves both this need and the one for a reasonably fast, high-quality medium telephoto for landscape and portrait work.

After the 28/35mm plus 80/100mm pairing, I would look next at a 19mm or 24mm Elmarit, probably followed by a 180mm f2.8 Elmarit. Looking even further ahead, this latter lens is particularly well matched with the 2x Apo Extender, so eventually the whole outfit could contain 19mm, 35mm, 100mm, 180mm and 360mm focal lengths of the highest quality.

From this point on, personal interests play an increasingly important role. I have already mentioned my acquisition of the PC lens and interest in close-up photography. Another speciality is photographing aircraft. For this, as with sports and wildlife photography, long, fast lenses are needed. I eventually bought the (now discontinued) 280mm f2.8 Apo lens and later added the a 1.4x Apo Extender, which gave me a 400mm f4 option. This is ideal, and fast enough to allow me to work with slower, high-quality films. I should emphasize that neither this lens nor my 28mm f2.8 PC are carried around as part of a standard outfit – I take them along only when a specific shoot or opportunity is likely to require them. My general-purpose R outfit consists of 19mm, 35mm, 50mm, 100mm and 80–200mm zoom lenses. Travelling light, the 35–70mm zoom is my choice.

GENERAL

The tables on pages 144 and 146 indicate the particular suitability of the various types of lens for particular applications and will help in making a selection. However, if at all possible make an opportunity to see and handle any lens you are thinking of buying. Comfortable, fumble-free handling is important if you are to get the best images regularly, and the satisfactory handling of a camera/lens combination is very much down to personal preference and method. Some of the R lenses are quite heavy and weight can become a serious disincentive when effort is needed to reach that 'best of all' viewpoint – so choose carefully.

AERIAL VIEW
This shot was taken from a hot-air balloon, from fairly low down with an ultra wide angle lens. The flight, on a crisp October morning, was a delight.
Leica RE, 19/2.8 Elmarit, 1/250 sec at f5.6, Fuji Provia 100

ULLSWATER, CUMBRIA, ENGLAND
Although the range from beyond 19mm up to 70mm is now conveniently covered by the R zoom lenses, I still like fast prime lenses to facilitate the use of slower, high-quality colour transparency film. The 35mm Summicron is one of my favourites in the R system as well as the M.
Leica RE, 35/2 Summicron, 1/60 sec at f5.6, Kodachrome 25 Professional

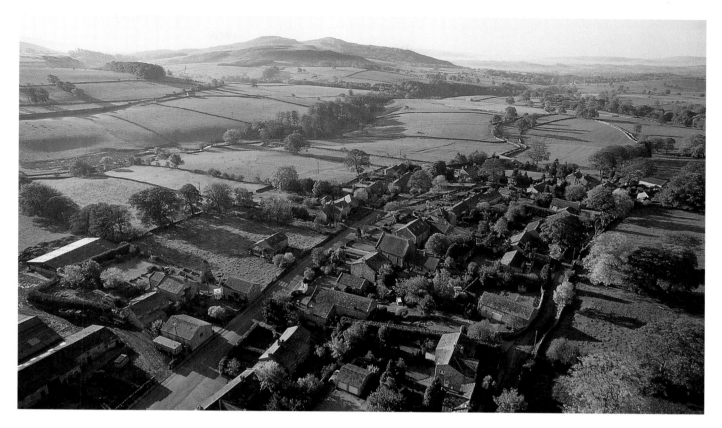

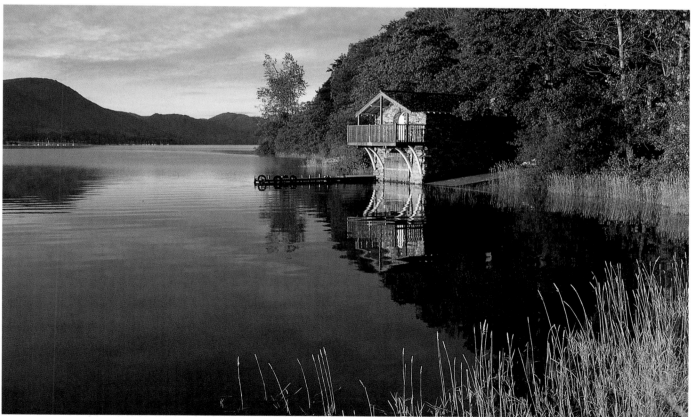

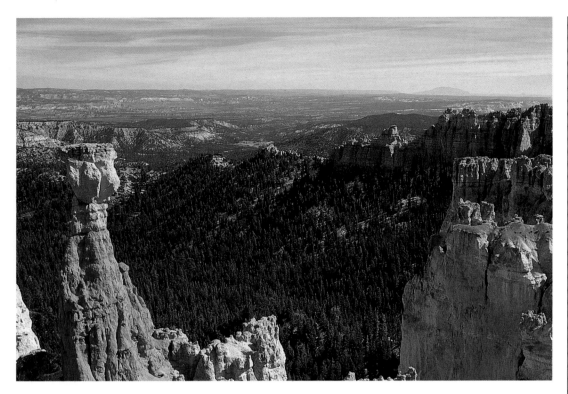

Bryce Canyon, Utah
No matter how many times I return, Bryce Canyon never fails to delight. You can get wonderful pictures there with almost any focal length lens.
Leica R8, 50/2 Summicron, 1/250 sec at f4/5.6, Kodachrome 25 Professional

VIEW FROM MARPLE RIDGE, CHESHIRE, ENGLAND
The latest 80–200mm zoom is a great lens. Here I was able to compose the landscape scene very precisely. The lens was set around the 150mm focal length.
Leica R8, 80–200/4 Vario Elmar, 1/500 sec at f5.6, Ektachrome 100 SW

THEATRE ROYAL, BATH, ENGLAND
The reflex system is especially versatile, with many special lenses. The 28mm Perspective Control lens is essential for serious architectural studies.
Leica RE, 28/2.8 PC Super Angulon, 1/60 sec at f5.6, Kodachrome 25 Professional

LEICA M LENSES APPLICATIONS

Lens	Focal length (mm) maximum aperture	General	Landscape	Travel	Photo-journalism	Nature & wildlife	Sport	Close-up	Portrait	Architecture
ELMARIT-M ASPH	21 f2.8	***	**	***	**	*	**	*	*	***
ELMARIT-M ASPH	24 f2.8	***	***	**	***	*	**	*	*	**
ELMARIT-M	28 f2.8	**	**	**	**	**	**	*	*	*
SUMMILUX-M ASPH	35 f1.4	**	**	**	***	***	***	*	**	**
SUMMICRON-M ASPH	35 f2	***	***	***	***	**	**	*	**	***
NOCTILUX-M	50 f1.0	*	*	*	***	**	**	*	**	*
SUMMILUX-M	50 f1.4	***	**	***	***	*	**	*	**	*
SUMMICRON-M	50 f2	***	***	***	***	**	**	***	***	***
ELMAR-M	50 f2.8	**	***	***	*	*	*	***	**	***
SUMMILUX-M	75 f1.4	*	**	*	***	**	*	*	***	*
APO-SUMMICRON-M ASPH	90 f2	***	***	***	***	**	***	**	***	**
ELMARIT-M	90 f2.8	***	***	***	**	**	**	***	***	**
APO-TELYT-M	135 f3.4	***	**	***	***	**	***	**	***	***
TRI-ELMAR-M ASPH	28/35/50 f4	***	***	***	**	*	*	*	**	*

*** Recommended ** Worth considering * Not well suited

STREET SCENE, SANA'A, YEMEN

Travel, photojournalism, people: these are strong areas for an M outfit with a 35mm lens as its cornerstone.

Leica M6, 35/2 Summicron, 1/60 sec at f2.8, Kodachrome 25 Professional

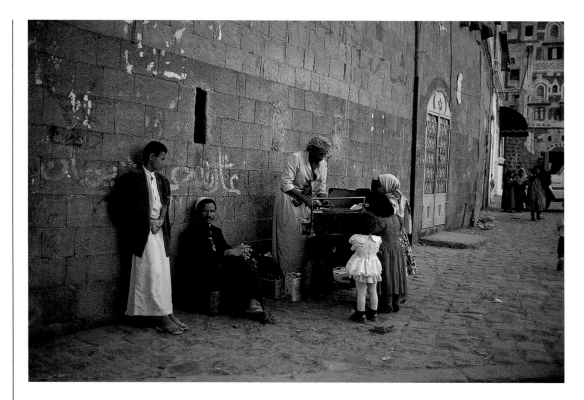

NEW YORK, USA

A detail picked out with the 90mm, probably the ideal companion to the 35mm when you wish to travel light.

Leica M6, 90/2 Summicron, 1/250 sec at f2.8, Kodachrome 25 Professional

LEICA R LENSES APPLICATIONS

Lens	Focal length (mm) maximum aperture	General	Landscape	Travel	Photo-journalism	Nature & wildlife	Sport	Close-up	Industrial	Portrait	Advertising	Architecture
SUPER ELMAR-R	15 f3.5	★	★★	★	★	★	★★	★	★★★	★	★★★	★★★
FISHEYE ELMARIT-R	16 f2.8	★	★	★★	★	★	★★	★	★★	★	★★★	★★
ELMARIT-R	19 f2.8	★★★	★★★	★★★	★★★	★★	★★★	★	★★★	★	★★★	★★★
ELMARIT-R	24 f2.8	★★★	★★★	★★★	★★★	★★	★★★	★	★★	★	★★	★★
PC SUPER ANGULON-R	28 f2.8	★	★★	★★	★	★	★	★★	★★★	★	★★★	★★★
ELMARIT-R	28 f2.8	★★★	★★★	★★★	★★★	★★	★★	★	★★★	★★	★★★	★★
SUMMILUX-R	35 f1.4	★★	★★★	★★	★★★	★★★	★★★	★	★★	★★★	★★	★★
SUMMICRON-R	35 f2	★★★	★★★	★★★	★★★	★★★	★★★	★★	★★★	★★★	★★★	★★
SUMMILUX-R	50 f1.4	★★	★★	★★★	★★★	★	★★★	★	★★	★★	★	★
SUMMICRON-R	50 f2	★★★	★★★	★★★	★★★	★★	★★★	★★	★★	★★★	★★	★★
MACRO ELMARIT-R	60 f2.8	★★★	★★★	★★★	★★	★★★	★★	★★★	★★★	★★★	★★★	★★
SUMMILUX-R	80 f1.4	★★	★★	★★	★★★	★★	★★★	★	★★	★★	★	★
SUMMICRON-R	90 f2	★★★	★★★	★★★	★★★	★	★★★	★★	★★★	★★★	★★	★★
ELMARIT-R	90 f2.8	★★	★★★	★★★	★★	★★	★★	★★	★★★	★★★	★★	★★
APO MACRO ELMARIT-R	100 f2.8	★★★	★★★	★★★	★	★★★	★★	★★★	★★★	★★★	★★★	★★★
MACRO ELMAR-R	100 f4	★	★	★	★	★★★	★	★★★	★★	★	★★	★
ELMARIT-R	135 f2.8	★★	★★	★★	★★	★	★★★	★	★	★★	★	★★
APO SUMMICRON-R	180 f2	★	★	★	★★★	★★★	★★★	★	★	★★	★	★
APO ELMARIT-R	180 f2.8	★★★	★★★	★★★	★★★	★★★	★★★	★	★★★	★★	★★	★★★
APO TELYT-R	280 f4	★	★★	★★	★	★★★	★★	★★	★★	★★★	★★	★★
APO TELYT-R	280 f2.8	★	★	★	★★★	★★★	★★★	★	★★	★★	★★	★★
APO TELYT-R	400 f2.8	★	★	★	★★★	★★★	★★★	★	★	★	★★	★
APO TELYT-R	400 f4	★	★	★	★★	★★★	★★	★	★	★	★★	★★
APO TELYT-R	560 f4	★	★	★	★★★	★★★	★★★	★	★	★	★★	★
APO TELYT-R	560 f5.6	★	★	★	★★	★★★	★★	★	★	★	★★	★★
APO TELYT-R	800 f5.6	★	★	★	★★★	★★★	★★★	★	★	★	★★	★★
VARIO ELMAR-R	28-70 f3.5/4.5	★★	★★	★★★	★	★	★	★★	★★	★	★	★
VARIO ELMAR-R	35-70 f3.5	★★	★★	★★★	★★	★	★	★	★★	★	★	★
VARIO ELMAR-R	35-70 f4	★★★	★★★	★★★	★★	★	★★★	★	★★★	★	★★	★
VARIO APO ELMARIT-R	70-180 f2.8	★	★	★	★★★	★★	★★★	★	★★	★★★	★	★★
VARIO ELMAR-R	80-200 f4	★★★	★★★	★★★	★★	★★★	★★	★★	★★	★★★	★★	★★
VARIO ELMAR-R	105-280 f4.2	★★	★	★	★★★	★★★	★★★	★	★	★★	★★	★

*** Recommended ** Worth considering * Not well suited

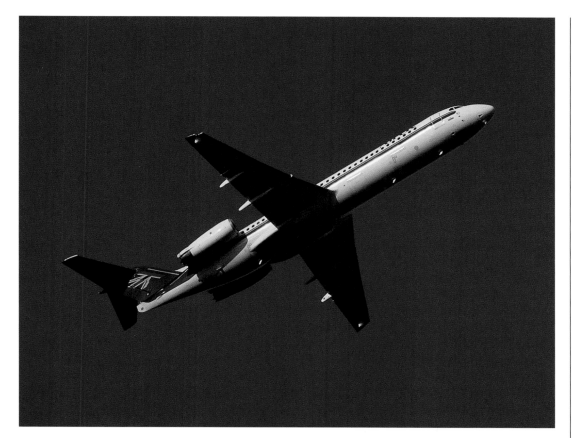

FOKKER 100

The versatile Leica reflex
system includes a fine
selection of long telephoto
options ideal for sport and
wildlife photography – not
to mention aeroplanes!
**Leica R8, 280/2.8 Apo Telyt
+ 1.4x Apo Extender,
1/1000 sec at f4/5.6,
Ektachrome 100 SW**

FALL COLOURS

Close-up photography is
another area where the
versatile R system has clear
advantages.
**Leica R4 60/2.8 Macro
Elmarit, 1/60 sec at f5.6/8,
Kodachrome 64**

TAKING CARE OF YOUR LEICA LENSES

Leica lenses, whether M or R, are built to last and designed to be robust and to 'take it'. The many older ones that are still around in perfect working order bear testimony to this. I have several lenses that I use fairly regularly which are over 20 years old. So far, none has ever required attention or even servicing.

HANDLING

Chapter 12 details some of the problems to look for when buying a used lens. Here, we are concerned with ensuring that our lenses never reach the 'problem' category. Most difficulties arise when a lens has been dropped on to a hard surface or used in particularly adverse conditions. Leica lenses do have very good shock resistance and dropping or knocking them against even a fairly hard surface will, more often than not, result in cosmetic damage only. Nevertheless, take care when changing lenses and try not to finish up needing three hands – easy enough when switching lenses between bodies.

Prevention is better than cure, so one practice I follow is to protect the lens with a filter such as UVa or Skylight 1A whenever possible. This keeps greasy fingers, rain, snow, sand, dust and so on off the vulnerable front element of the lens and is much easier and safer to clean. I also try to avoid changing lenses in particularly adverse conditions, such as by or on the sea, at the beach or in certain industrial situations. Salt spray is highly damaging to both the optical and mechanical parts of the camera and lens, as are sand and other fine particles. If you are likely to need different focal lengths, these are situations where a zoom lens is especially valuable.

CARRYING

A well-made, well-padded outfit case is a good investment. Practicality takes precedence over elegance when you have to stuff your case under an aircraft seat or in an overhead locker, or when you are bouncing around the landscape in a 4x4 or slipping down some rocky slope. A more mundane but perhaps more frequent occurrence is the case that flies off the car seat as

TREGASTEL, BRITTANY, FRANCE

Fine sand and salt spray from the sea are potentially very harmful to cameras and lenses. Be careful when and how you change lenses; keep a filter on the lens and store those not in use in plastic bags.
Leica M6, 35/2 Summicron, 1/250 sec at f5.6/8, Kodachrome 25 Professional

you brake suddenly or take a corner rather quickly! Choose a bag that will handle these situations.

Aluminium cases with foam inserts are fine and probably give the best protection, but they are not as easy or convenient to work from as the conventional soft case. My preference is a medium-sized Billingham. There is a good range, they are very well made (in England) and are very much the choice of the professionals. I also use a Tamrac 'Day-pack', which doubles as an outfit case and backpack. Within the bags, the lenses are carried in soft leather bags for added protection. The harder cases that Leica lenses are now supplied in, while giving excellent protection, are generally too bulky. However, they are very useful when carrying lenses 'loose' in a bag not fitted with proper slots for the various items.

To make maximum use of space, I also use the Leica connectors that allow two lenses to be stored back to back. Do be careful when using the M connector, however: this is open ended and the wide angle lenses with projecting rear components can easily foul the rear of the companion lens.

LENS ACCESSORIES
Front or rear lens caps are there to protect your lens when stored. The soft pouch case gives added protection in the gadget bag. A UVa or Skylight filter gives protection when the lens is in use. The back-to-back caps shown save space in the gadget bag, but be careful with the wide angle rangefinder lenses: the projecting rear element means that the 'pairing' lens has to be chosen carefully!
Leica R8, 100/2.8 Apo Macro Elmarit, 1/2 sec at f16, Ektachrome 100 SW

CLEANING

For best performance, lenses must be kept clean. Generally, it is the front element that suffers most, but if you follow the advice above and keep a filter on whenever possible it will only be the relatively inexpensive filter that requires regular attention.

Remove any loose particles of dust, grit and so on with a blower. You may need to use a soft camel-hair lens brush to loosen more reluctant dirt. Breathe gently on the lens or filter and wipe it with a clean microfibre lens cleaning cloth. Try to do this in one smooth action: vigorous polishing is neither necessary nor desirable, and the microfibre cloth will remove grease, finger marks, rain spots and so on with the help of the warm moisture provided by breathing on the surface.

The above procedure is one that I have used for several years now and is Leica's current recommendation. Leica themselves supply a particularly good lens cleaning cloth which you should be able to buy from your dealer. Wash the cloth regularly in warm (not hot) soapy water and rinse thoroughly before drying. Carry the cleaning kit in your gadget case in a plastic bag to keep out dust and dirt.

Do not use the specially impregnated cloths or tissues supplied for cleaning spectacles; lens cleaning fluids also may be

LENS CLEANING KIT
Microfibre lens cleaning
cloths, a blower and a
retractable soft camel hair
brush are all that are
needed. Clean gently.
**Leica R8, 100/2.8 Apo
Macro Elmarit, 1/2 sec at
f16, Ektachrome 100 SW**

suspect. The chemicals these contain may be harmful to the optical glass and the surface coatings on camera lenses or could affect the lubricants and adhesives used. A little water is all that Leica recommend.

SERVICING AND REPAIRS

'If it ain't broke, don't fix it' is a good rule to apply to lenses. Leica lenses do not rely on excessive amounts of lubricant to provide smooth focusing or diaphragm operation, so in the absence of serious maltreatment it will be many, many years before any attention is required. With older lenses stored in adverse conditions, the lubricants may have dried out and the focusing become stiff. This, and a sticking auto-diaphragm (infrequent), are the items likely to need attention and will be self-evident. Servicing on a regular basis is not necessary and any attention that is required should be entrusted only to a Leica agency or an approved repairer.

Similarly with repairs: not only is it important that a repair is carried out properly with the correct materials, but checking out a lens for correct alignment and focusing accuracy after the repair requires specialist equipment. Your Leica lens is precious – don't cut corners!

FOLLOWING PAGES
AL HAJJARAH, YEMEN
Travelling in the more
remote areas, and on rough,
dusty roads, can be tough
on photo equipment. The
Leica and its lenses are
robust and 'can take it' but a
little loving care never goes
amiss! For the last couple of
miles up to this location our
pick-up truck was
negotiating a boulder-strew
track so I was very glad of
a well-padded bag for my
M gear!
**Leica M6, 21/2.8 Elmarit,
1/125 sec at f5.6/8,
Kodachrome 25
Professional**

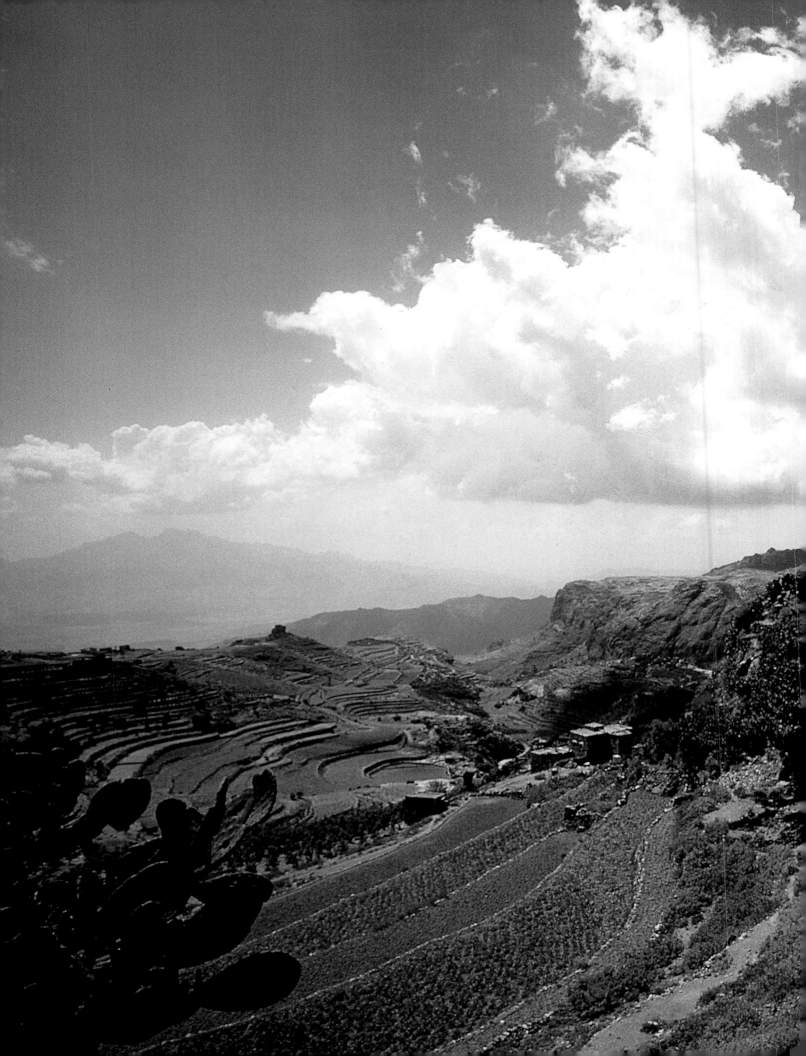

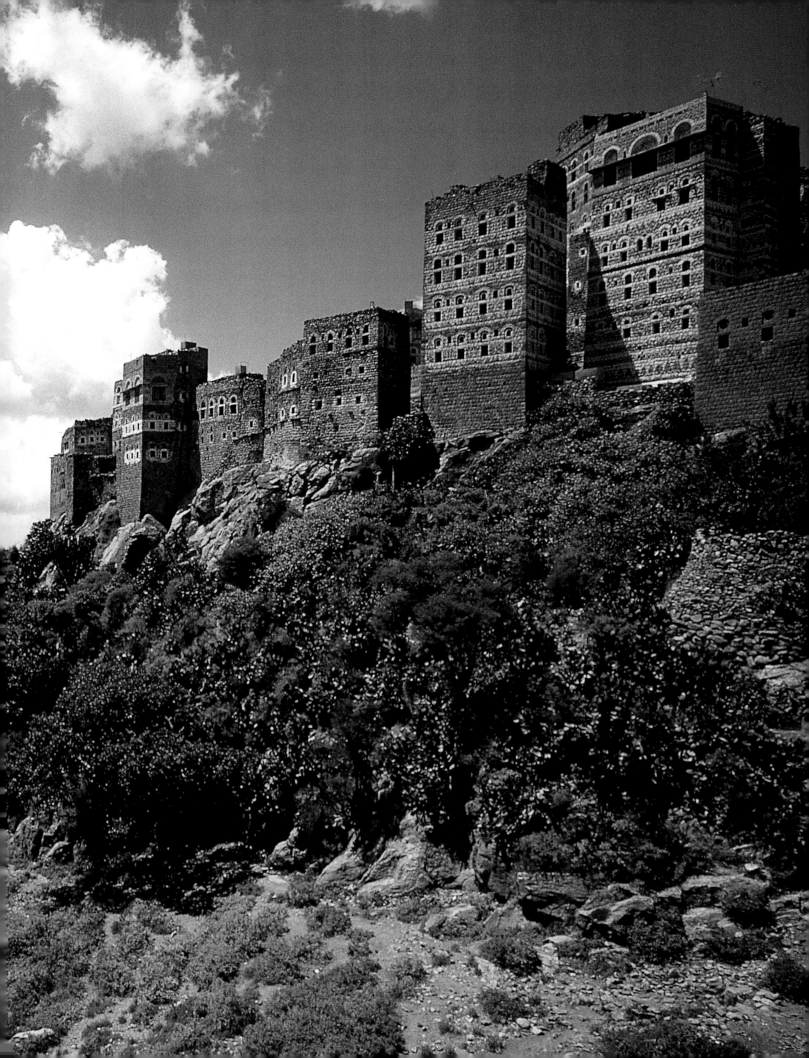

BUYING SECONDHAND

For those on a limited budget, or where a particular lens is needed only infrequently, a used lens in good condition is a perfectly viable option. Certainly in my early Leica days a significant proportion of my equipment was acquired 'used' or 'demonstration soiled'.

There is a very active market for used Leica equipment. As well as the many specialist dealers, the various Leica societies circulate details of members' items available for sale or swap, and, of course, the classified advertisements in photographic magazines are a useful source.

Generally speaking, Leica cameras and lenses are very well cared for by their owners. The intrinsic quality as well as the cost encourage respect, and in any case the exemplary build quality ensures that performance is maintained over a very long period. With reasonable care, lenses in particular can be expected to give many, many years of trouble-free service. I have already mentioned that I have several lenses, M and R, that I use fairly regularly which are over 20 years old. They still work impeccably and, for the particular applications for which I need them, are not significantly behind the very latest versions in terms of performance.

GENERAL

Look for any external damage to the mount. Any bad dents or abrasions could indicate a severe knock that might have caused internal damage or displaced lens elements. Slight scuffing or marks are of no practical significance, but even these relatively minor imperfections should be reflected in the asking price.

SUMMICRONS ALL
Buying secondhand means knowing your lenses. Five versions of the 50mm Summicron, **LEFT TO RIGHT:** 1979, 1975, 1997, 1967, 1954 collapsible. The 1979 and 1997 versions are optically identical: each of the others is optically different! They are all first-class performers and each in its day was the standard against which all other 50mm lenses were judged. **Leica R8, 100/2.8 Apo Macro Elmarit, 1/4 sec at f16, Kodak T 400 CN**

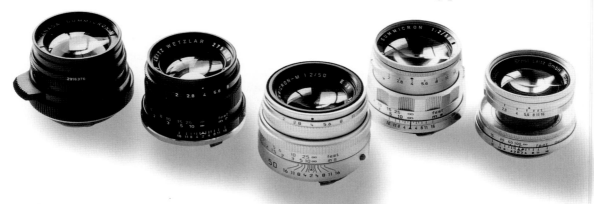

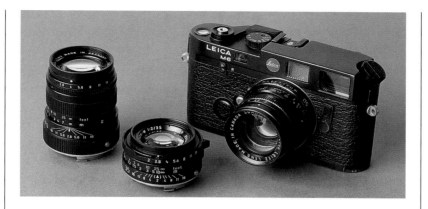

Examine the front and rear lens surfaces with a magnifier: one or two very slight scratches or a tiny chip near the edges of a surface will not affect performance to any significant degree, but a network of fine scratches, often caused by over-enthusiastic cleaning, will cause loss of definition and contrast.

Similarly, a few specks of dust inside the lens do not matter. However, fungus growth, condensation deposits or even some serious breakdown of the balsam or other adhesives used to cement lens elements together are very bad signs, calling for expensive stripping and repair before the lens can be used. Look also for oil on the diaphragm blades, which may be an indication of unskilled attention at some stage. The tiniest possible trace on very old lenses may be acceptable, but all recent lenses (including all R lenses) have diaphragm blades coated with Teflon and do not require any lubrication.

If the lens has any serious faults, think very carefully before buying. Proper attention to a faulty lens, preferably by Leica or one of its official agencies, is expensive and unlikely to be an economic proposition.

R LENSES

The first thing to check out on any R lens is the camming arrangement. Is it single cam, twin cam, triple cam or R cam only? Does it have the ROM contacts for the R8? Chapter 6 will enable you to identify this, and the camera listing in Chapter 1 (the table on page 12) indicates the compatibility with the various R models. Your best bet is probably triple cam – which fits all models – or R cam with or without ROM contacts, which fits all R3 and later models.

While checking the cam arrangement at the rear of the lens, test the auto diaphragm mechanism. Set the lens at the smallest stop – f16 or f22 – pull back the operating arm to open the diaphragm fully and then release it. The diaphragm should immediately spring back freely and positively to the set stop without any stickiness or hesitation.

While the lens is off the camera, check at each aperture setting that the lens clicks into the range of stops and that the

USED M OUTFIT
An M6 plus three basic lenses form a high-quality, remarkably portable and cost-effective outfit. The 50mm Summicron lens on the camera is of 1979 Canadian manufacture but optically identical to the current German lens. The 35mm f2 Summicron (code 11310) was only recently discontinued and an excellent performer, while the 90mm f2.8 Tele-Elmarit, discontinued in 1990, is one of the nicest 90mms and especially light and compact.
Leica M6, 90/2.8 Elmarit, 1 sec at f11, Ektachrome 100 SW

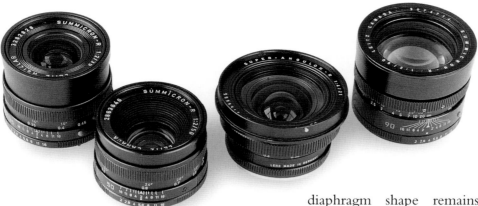

diaphragm shape remains regular throughout the range. This will indicate if one of the blades is damaged or sticking.

Put the lens on the camera: it should go on smoothly and lock firmly. Check that the image it gives in the viewfinder is clear and sharp, the focusing action smooth and that the lens focuses to infinity. Infinity needs to be a good distance away: my test subject is the local church steeple, which is a good 0.8km (½ mile) from home, and even this is not infinity with long focal length lenses!

Be aware that many of the longer Leica lenses will focus past the infinity setting marked on the lens. This is to facilitate critical focusing at or near infinity and allows some tolerance when fitting the extenders.

Make sure that the lens is operating correctly with the camera body – in particular that it is stopping down when the shutter is fired and that it is metering accurately.

M AND SCREW-MOUNT LENSES

Mechanically, the rangefinder lenses are very simple and robust. Having carried out the general checks indicated above, the main area of concern is to ensure that the lens is coupling accurately with the rangefinder. For this you will need a body and preferably also a lens that are known to be adjusted accurately. Put the lens on the body. With the M bayonet, it should fit smoothly and lock positively with no play. Make sure that the correct focal length frame comes up in the M viewfinder. When fully home, a screw-mount lens should finish with the distance scale more or less central at the top.

Check that the lens couples correctly with the rangefinder at infinity. Again, choose a suitably distant object such as my church steeple. Generally speaking, if the coupling is accurate at infinity all should be well throughout the focusing range, but a comparison with the 'known' lens can be useful. Around 10m (30ft), 3m (10ft) and 1m (3ft) are suitable distances to check out. Older lenses with removable lens heads ought to have the lens

serial number or its last three digits marked inside the focusing mount barrel. As lens cams are individually adjusted, it is always worth ensuring that the lens head has the correct barrel.

The diaphragm should be sufficiently positive. The focusing action also needs to be smooth – neither too stiff nor too sloppy. An older lens may be a little stiff from lack of use, so some 'working' may well free it up sufficiently.

FURTHER CONSIDERATIONS

Do your homework. Familiarize yourself with the price range of the lens that you are seeking to buy and ensure that you can identify the particular model and its age. Check whether or not a lens hood (if not built in) and maybe even a filter is included: lens hoods and some odd sizes of filter can sometimes be extremely difficult to find or buy separately and in some cases are very expensive. Rangefinder lenses, more so than R lenses, are very much in the collectors' domain, although they will usually be looking for rare items or lenses in exceptional condition. These may not necessarily be of interest to the photographer requiring a lens to use rather than show off in a display cabinet. Do not pay collector prices for normal items or those in only average condition. If the original box is with the lens, keep it – a boxed lens usually attracts a small premium which will be reflected in any subsequent resale. Haggle to get lens hoods, filters, boxes, and so on, included in the price as a 'sweetener' to the deal.

FINALLY

There is plenty of money to be saved by buying secondhand. Most current and recent lenses of the more common focal lengths are in good supply, so shop around for the latest models and those in best condition, within your budget. Chapters 5 and 6 give guidelines on what to look for and the likely age of particular models. However, if you are relatively new to the Leica scene a reliable specialist dealer can be a valuable friend. Buying privately can be cheaper but obviously demands more knowledge and an ability to check out condition on the spot, as there is unlikely to be any comeback should there be a problem!

REMOVABLE LENS HEAD

Many earlier M and screw-mount lenses had lens heads that could be removed for use on various close-up devices or Visoflex focusing mounts. As lenses were individually matched to the rangefinder focusing mount, it is important that the right head goes on the right mount. The lens serial number (or sometimes just the last three digits) is engraved or scratched on the mount.

Many lenses also have the exact focal length indicated. This nominal 50mm lens is actually 51.9mm. The '19' next to the 'feet/m' engraving is the clue. Thus '05' on a 90mm lens would mean that the precise focal length of the lens is 90.5mm.

Leica R8, 100/2.8 Apo Macro Elmarit, 1/4 sec at f16, Kodak T 400 CN

BIBLIOGRAPHY

LEICA PHOTOGRAPHY

Bower, Brian *Leica Reflex Photography* (David & Charles)

Bower, Brian *Leica M Photography* (David & Charles)

Bower, Brian *Lens, Light and Landscape* (David & Charles)

Eastland, Jonathan *Leica M Compendium* (Hove Books)

Eastland, Jonathan *Leica R Compendium* (Hove Books)

Frey, Verena *75 Years of Leica Photography* (Leica Camera AG)

★ Haas, Ernst *The Creation* (Michael Joseph)

Handbook of the Leica System (Leica Camera AG)

★ Kisselbach, Theo *The Leica Book* (Heering Verlag)

Laney, Dennis *Leica Lens Practice* (Hove Books)

Magnum *In Our Time* (Andre Deutsch)

★ Matheson, Andrew *The Leica Way* Various editions (Focal Press)

★ Morgan *The Leica Manual* Various editions (Morgan & Morgan)

★ Osterloh, Gunter *Leica M* (Umschau Verlag)

★ Osterloh, Gunter *Applied Leica Technique* (Umschau Verlag)

Salgado, Sebastiao *Workers* (Phaidon)

★ Scheerer, Theo *The Leica and the Leica System* (Fountain Press)

★Although these books are out of print, some for many years, they are recommended as being particularly informative on older equipment and are worth seeking out privately or from secondhand bookshops and camera dealers.

LEICA COLLECTORS' GUIDES

Hasbroeck, Paul Henry *Leica, a history illustrating every camera and accessory* (Sothebys)

Lager, James *Leica: An Illustrated History* Volume I Cameras (Lager Limited Editions)

Lager, James *Leica: an Illustrated History* Volume II Lenses (Lager Limited Editions)

Laney, Dennis *Leica Collectors' Guide* (Hove Books)

Laney, Dennis *Leica Pocket Book* (Hove Books)

Nakamura, Shinichi *Leica Collection* (Asahi Sonoram)

LEICA MAGAZINES

Leica Fotografie (Umschau Verlag), 8 issues per year

Viewfinder (Leica Historical Society of America), quarterly

LHS Newsletter (Leica Historical Society – UK), quarterly

INDEX

ACKNOWLEDGEMENTS

As with all my books, the constant support and help of my wife Valerie has been absolutely invaluable. Not only is she ever tolerant of my obsession for photography and fascination with the Leica, but she has keyed the text, helped me with the editing and later the proof checking! Over the years many colleagues and friends, too numerous to mention individually, have also humoured my enthusiasm and been patient and helpful with my photographic activities. I am grateful to all of them. My many friends at Leica Camera AG have given me unhesitating co-operation and assistance and I would particularly like to thank Hans Gunter von Zydowitz, Uli Hintner, Sonke Peters and Enrico Domhardt for their time and patience with my constant requests for information. At David & Charles my special thanks go to Piers Spence, Editorial Director, Freya Dangerfield and Fiona Eaton, my Editors, and Brenda Morrison, the Chief Designer, my main points of contact, but I wish also to mention the entire team, editorial, production and marketing whose skills and effort are truly appreciated.